Puget Sound

SEA BETWEEN THE MOUNTAINS

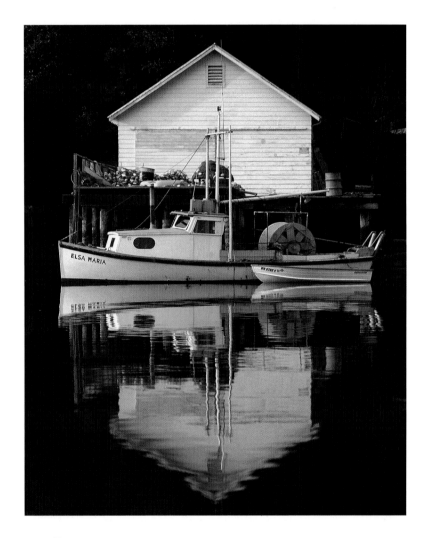

Photographs by Tim Thompson

Text by Eric Scigliano

GRAPHIC ARTS CENTER PUBLISHING®

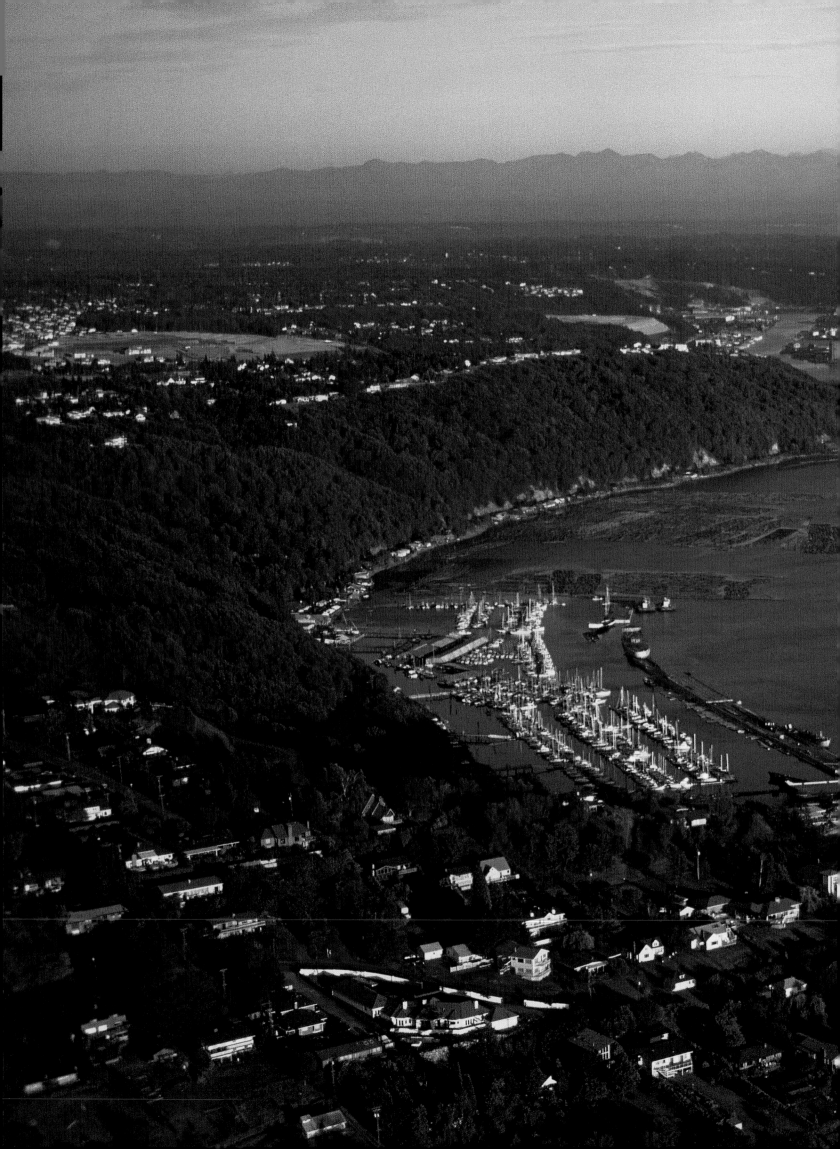

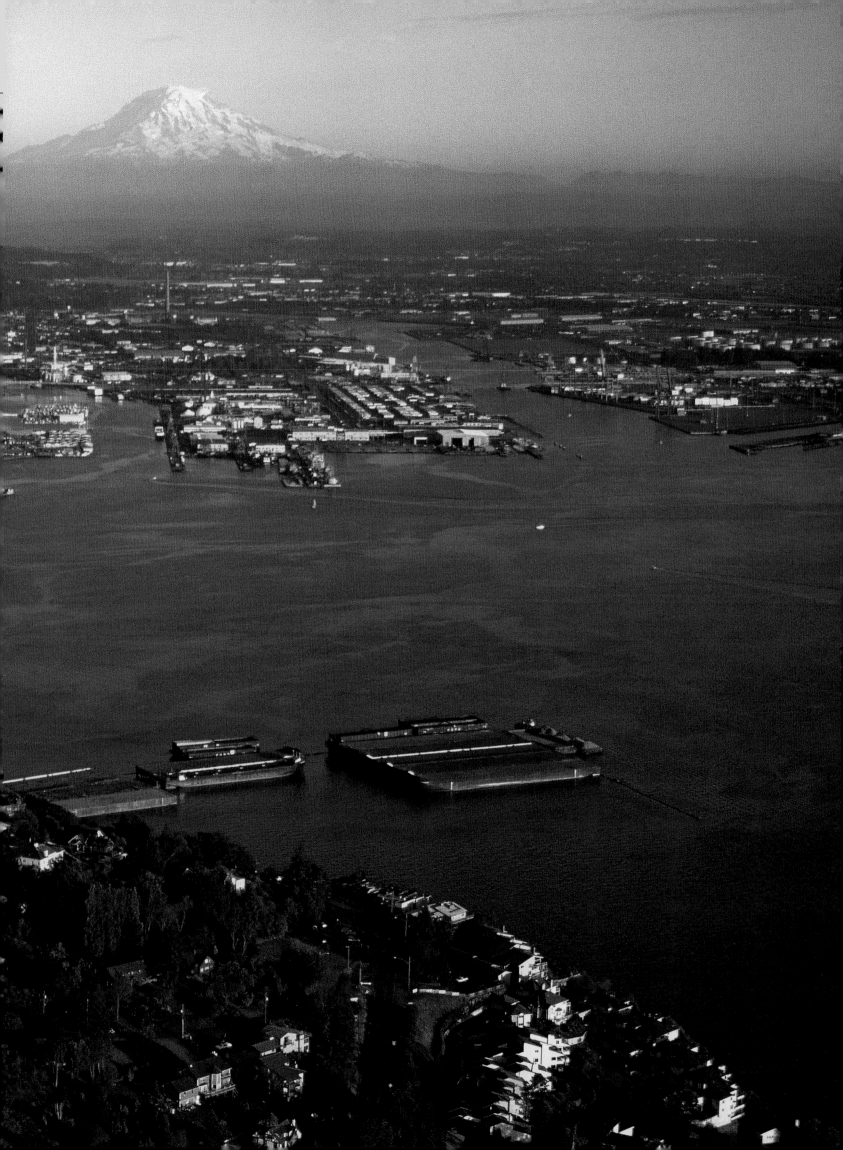

*To my wife Eva, who has been long
on patience and encouragement during
this project; and to my two boys,
Brandon and Darrin, who on more
than one occasion, have brought back
better images than my own.*

—TT

*To my daughter Kate,
born and bred by Puget Sound.*

—ES

Photographs © MM by Tim Thompson
Text © MM by Eric Scigliano
Book compilation © MM by Graphic Arts Center Publishing®
An imprint of Graphic Arts Center Publishing Company
P.O. Box 10306, Portland, Oregon 97296-0306, 503-226-2402
www.gacpc.com

Library of Congress Cataloging-in-Publication Data
Thompson, Tim, 1942–
 Puget Sound: Sea Between the Mountains / photography by Tim
Thompson ; text by Eric Scigliano.
 p. cm.
 ISBN 1-55868-407-7 (alk. paper)
 1. Puget Sound Region (Wash.)—Pictorial works. 2. Puget Sound
 Region (Wash.)—Description and travel. I. Scigliano, Eric, 1953–
 II. Title.

 F897.P9 T48 2000
 979.7'7—dc21 99-058711

Pages 2-3: Tacoma, the Sound's second city, spreads along the deep
waters of Commencement Bay, beneath the great volcano it was named
after and which the world now calls Mount Rainier.
Pages 4-5: Light dances and swans glide on Bainbridge Island's
Manzanita Bay, just ten miles from the urban swarm of downtown Seattle.
Pages 6-7: The Friday Harbor ferry is the only "highway" to the
San Juan Islands' county seat.

President/Publisher: Charles M. Hopkins
Editorial Staff: Douglas A. Pfeiffer, Ellen Harkins Wheat,
 Timothy W. Frew, Tricia Brown, Jean Andrews, Alicia I. Paulson,
 Julia Warren
Production Staff: Richard L. Owsiany, Heather Doornink
Designer: Elizabeth Watson, Watson Graphics

Printed in Hong Kong

CONTENTS

Map . 6

The Inner Sea

PART I

TERRA INCOGNITA 9

 Portfolio: *The City between the Waters* . . 14

PART II

THE SEAWOLF 41

MARE NOSTRUM 43

WHULGE . 45

DANGEROUS BEAUTY 48

 Portfolio: *Inlets and Outcrops* 52

PART III

OYSTER LIGHT 67

UPWELLINGS 69

LORDS OF THE SOUND 73

POTLATCH 77

 Portfolio: *The Cascade Corridor* 80

PART IV

WUNDERKINDER 95

TECHREPRENEURS 99

GENTRIFICATION 103

THE SEAWOLF'S FATE 106

THE WISE WASGO 109

Bibliography . *111*

Acknowledgments . *112*

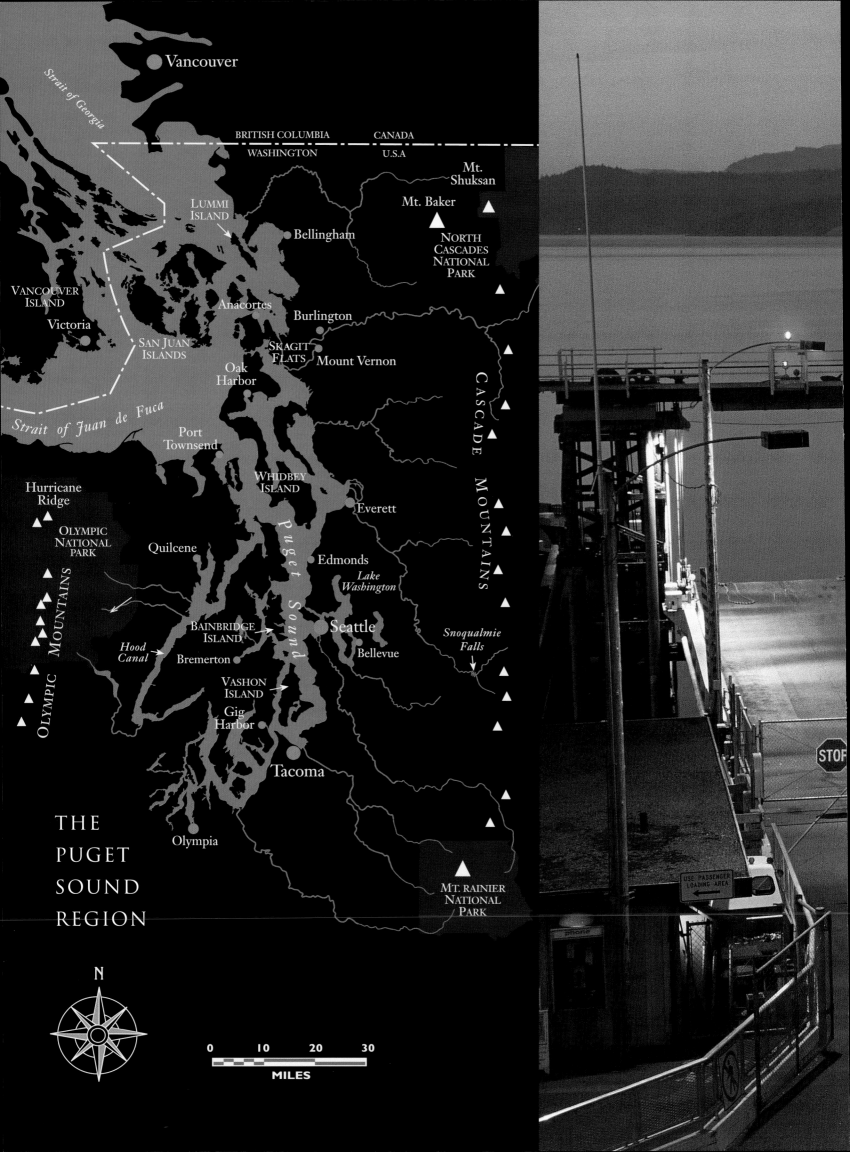

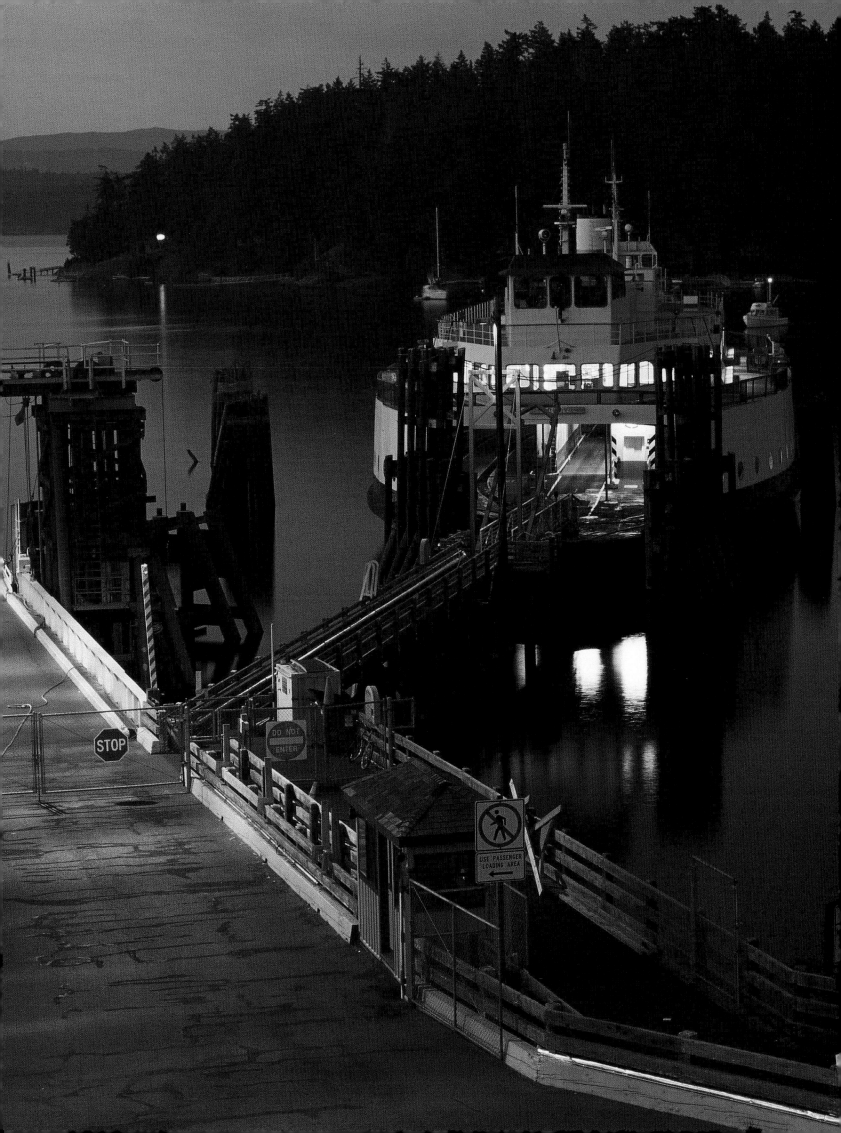

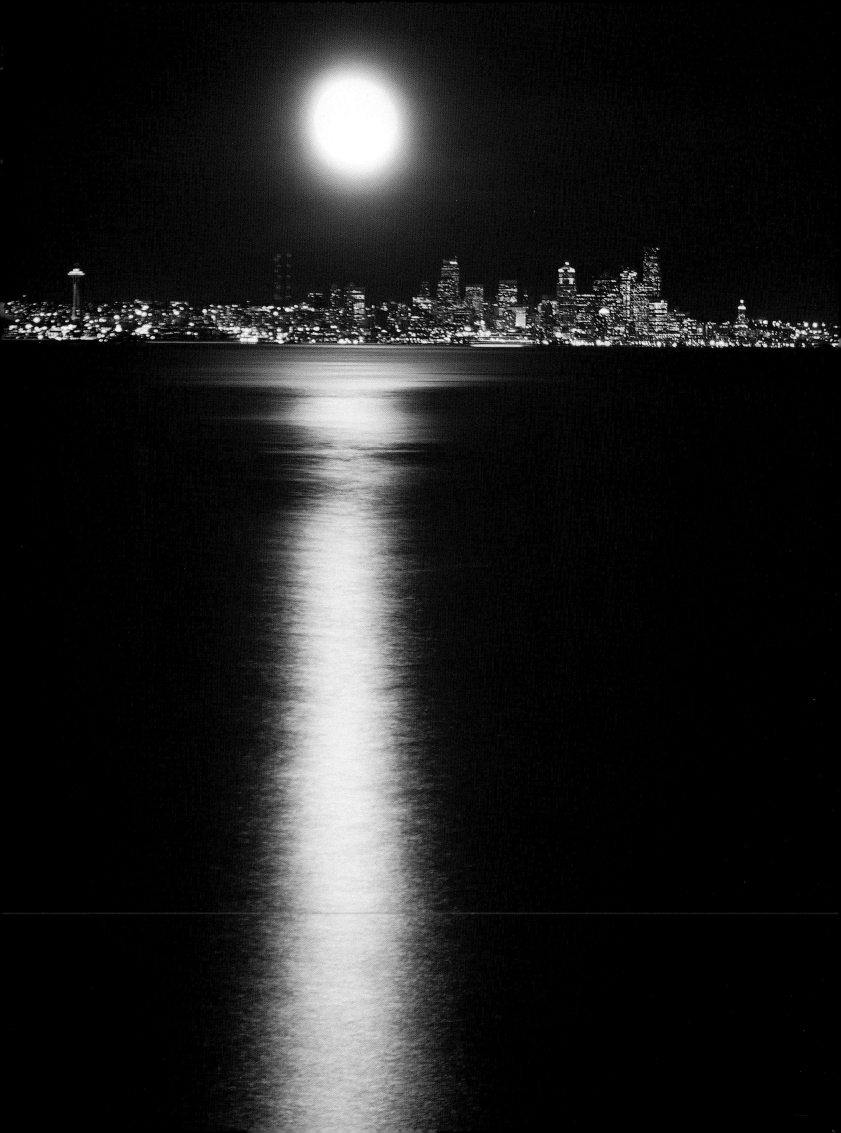

The Inner Sea

PART I

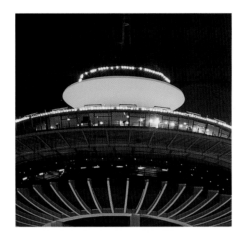

TERRA INCOGNITA

·

I grew up almost everywhere except the Pacific Northwest, amid Midwest cornfields, rustbelt smokestacks, Southwest mesas, California freeways, tidewater bays, even tropical jungles. And so this one corner of the country remained *terra incognita*, the outer edge, where America drifted off to gaping ocean or frozen Arctic. This was the one part of the country where no one I knew had ever been except my father, who in 1946 opted to ship out of the Navy in Bremerton because he got a travel allowance for being stranded in so remote a spot. He kicked around Seattle for a bit, and noted that it had unusually steep hills and sturdy-legged women. But he headed south to check out California and, as it turned out, to meet my mother.

Over the years our peripatetic family crisscrossed the country, east and west and north and south, traversing most states and every region save one. The Northwest alone was not on the way to anyplace else, except Alaska; even when we moved across the Pacific, we caught a ship from Los Angeles.

Like the old cartographers' "Emptye Africa," the Northwest was a bare spot on the mental map, to be filled in with imaginings. But imagination had helpers—a few alluring icons that seemed to reach through the fog and disclose this hidden realm. Foremost was the Space Needle—a nostalgic Flash

◄ What might the pioneers, who named their first Elliott Bay settlement "New York Alki (Someday)," say if they saw Seattle's skyline gleaming across the bay today?

▲ The restaurant and observation decks of the Space Needle, yesteryear's beacon of the future.

LIKE THE OLD CARTOGRAPHERS' "EMPTYE AFRICA," THE NORTHWEST WAS A BARE SPOT ON THE MENTAL MAP, TO BE FILLED IN WITH IMAGININGS.

Gordonesque artifact, but still a beacon of vision and promise, of better living through technology. I remember puttering with my first stamp album at the kitchen table, staring at the new commemorative for the 1962 Seattle World's Fair, with the Space Needle rising, bold and sharp as a blade, over the humdrum landscape: Who would dare build such a thing? And there were other iconic tokens, seen on postcards, book jackets, and beer bottles: Mount Rainier, brash and impossibly big, a snow cone towering over trees so thick they seemed like green fur. There were strange, bulbous boats, white and green and, in one case, glittery silver, sailing on dark channels between the green fur. Everywhere there was the water, so dark and opaque it seemed almost solid, above which the human and natural monuments rose.

There was the name of that water, incongruously francophonic, at once graceful and faintly obscene, so strange and, for one who'd only read and never heard it, elusive of pronunciation. Was that *Pooh-get Sound? Pooh-jet Sound? Pyoo-jet Sound?* I would roll the syllables over and under like a sour candy, trying to get a purchase on them. What sort of place could have such a name?

Puget Sound. It dripped with mystery and contradictions. *Puget* sounded scarcely English, vaguely Indian—a fit companion to Pysht, Puyallup, and Suquamish—and very French. Later, in Provence, I noticed villages named "Puget-ville" and "Le Puget."

And there was *Sound* itself, a term at once austere and exotic. The other names we give inland extensions of the ocean—*bay, gulf, inlet*—are Latinate and prosaic. But *sound* is of stout Nordic origin; it descends from the Old English and Old Norwegian *sund*, which means variously "swimming," or "a strait," or "fish bladder"—perhaps some words are better left untranslated. Regardless, it's apt, for phonic and etymological reasons, that most of the world's saltwater sounds lie at its northern margins, in Scotland, Alaska, and the Canadian Arctic. As I gazed at the maps, the term evoked murky depths and chill northern winds. It only enhanced this region's air of remoteness, even after I finally arrived here twenty-four years ago.

To someone who knew both the lower, denser forests and crowded cities of the Eastern states and the high, empty vistas of the Southwest, this country seemed strange and strangely familiar. Even in downtown Seattle, the passing human parade seemed anachronistically, almost disconcertingly, pale, but diverse in other, subtler ways. I visited friends in a tiny town on the ocean coast whose

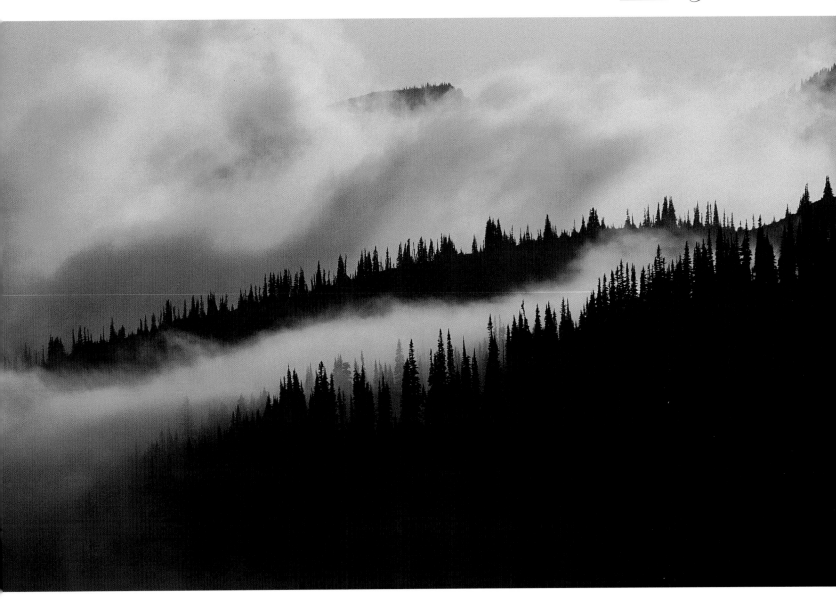

son was, as far as they knew, the only African-American child in the county. He was something of an exotic celebrity, indulged, even spoiled, by the community. Not that racial prejudice was unknown in his town; it was directed toward the local Indian tribes.

Where other cities had Chinatowns, Seattle had an "International District"—a nod to the Filipinos, Koreans, Japanese and, later, Indochinese refugees who also shared its storefronts and apartment buildings. A fiery orange Japanese windsock flew atop the Smith Tower, the stately patriarch of Seattle downtown high-rises, which was then owned by a fish-and-chips vendor of Scandinavian descent. Just up First Hill from the tower, I wandered into a Japanese *Bon Odori* street festival and felt transported to Kyoto. Nearby, in the Central District, the heart of Seattle's African-American community, I ate barbecue as good and fiery as any I'd known back East. Farther out Rainier Avenue, I

▲ Sometimes you see Mount Rainier/Tahoma, often you don't; here its foothills, viewed from the Paradise Valley, are swathed in fog.

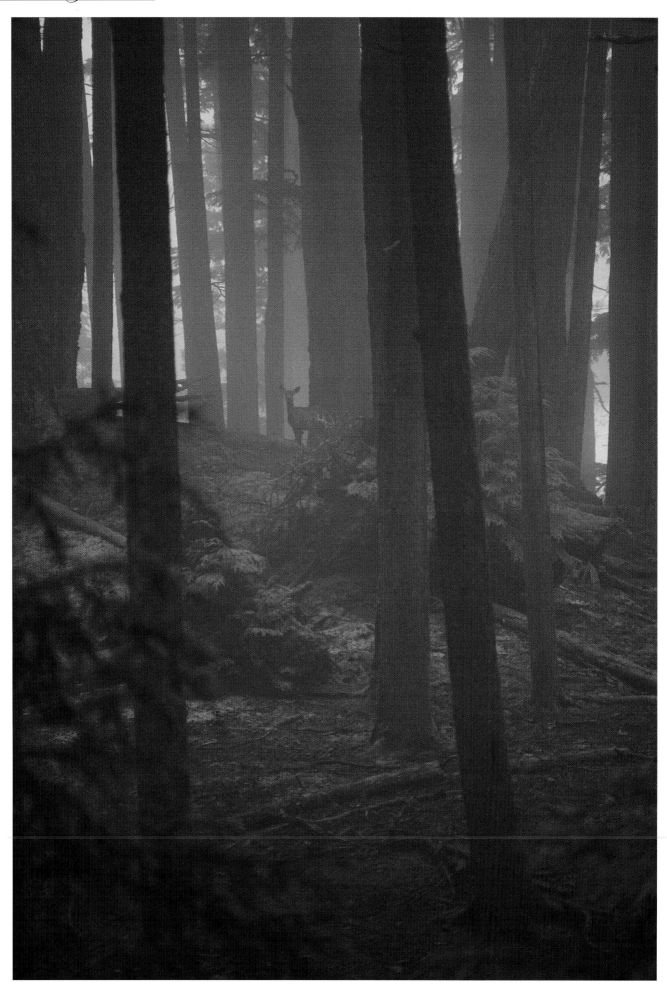

found the remnants—a deli, a wine shop, a parish church—of "Garlic Gulch," the old Italian community scattered by an overbearing freeway project. Out past Salmon Bay, the old fishing and boat-building community of Ballard was still stoutly and unmistakably Scandinavian (though gentrification and homogenization have since overtaken it as well). Up north, in the Skagit Valley farm town of Stanwood, half the signs were painted in ornate Norwegian rosemaling—and they hung over banks and feed stores, not tourist shops.

Yes indeed, things were different out here. The forests were thicker and lusher than any I'd seen before, and not only firs and hemlocks grew to outlandish heights. Dandelions became yard-high bushes in the damp Puget Sound spring. Blackberry vines twisted in thirty-foot whips, with thorns as big as arrowheads and sharp as fishhooks. They grew so fast they were nearly animate, piling up like the folds of a turban, twining over everything in their path: flowerbeds and swamps, cars and sheds. They snagged and tore at all who passed, but also gave with potlatch generosity—dripping masses of sweet berries, enough to feed a troop of bears, here in the middle of the city.

I felt like one of those bears when I first landed in Seattle; I could not stop eating the berries, filling my face and ruining my clothes with their pulp, heedless even of the auto exhaust that tainted them. Imagine then how the first European explorers and immigrants must have felt when they steered into these calm waters after so much seaborne tossing and saw, rising straight up from the shore and covering every hill and dale, the *trees*—two hundred, three hundred, nearly four hundred feet tall. We know some newcomers felt uneasy, even dismayed, perhaps even terrified; the women of the Denny party wept, in the dank November drizzle, when they landed at Alki point in 1851 and beheld the wilderness they were consigned to. They could hardly guess that before the century turned, their frail colony would beget a brash and roaring city, which, by the time the next century ended, would stand as one of the most powerful and glamorous cities in the world. These pioneers were earnest farming folk, for whom trees meant stumps that must be cleared and shade that must be opened. Surely they felt diminished by the sheer living mass before them and reached to their Bibles for consolation. But did they also feel an exhilaration, the sense of limitless possibilities that has, again and again, seized this region and led it to achieve things the rest of the world could not imagine? Did they wonder what else might grow where such trees could?

THE WOMEN OF THE DENNY PARTY WEPT, IN THE DANK NOVEMBER DRIZZLE, WHEN THEY LANDED IN 1851 AND BEHELD THE WILDERNESS THEY WERE CONSIGNED TO. THEY COULD HARDLY GUESS THEIR FRAIL COLONY WOULD BEGET ONE OF THE MOST POWERFUL AND GLAMOROUS CITIES IN THE WORLD.

◄ A deer peeks warily through deep woods on the slope of Orcas Island's Mount Constitution, the highest point in the San Juan Islands. Atop the mountain, the view opens to sweeping vistas of the Sound, straits, islands, and distant peaks.

The City between the Waters

Seattle's wasp-waisted shape, squeezed between Lake Washington and Elliott Bay and sectioned by the Ship Canal and Duwamish River, assures that water is always near and often in sight. Like downtown Hong Kong, downtown Seattle is compacted by geography: rich in views, short on space, and driven to push upward. And so its skyline is taller and more imposing than those of cities many times its size—while a few miles away eagles roost and salmon still struggle upstream to spawn.

▶ When the Seattle Art Museum installed one of more than twenty *Hammering Men* that artist Jonathan Borofsky has placed around the world, some critics howled that it was too vapid and generic. Many Seattleites cheered when, on Labor Day 1993, the "Subculture Joe" guerilla artists locked a seven-hundred-pound ball and chain on *Hammering Man's* ankle. But today, minus the ball and chain, the forty-eight-foot steel silhouette is an essential city landmark, evoking Seattle's radical labor history and the commercial dynamism that has sent its skyline soaring.

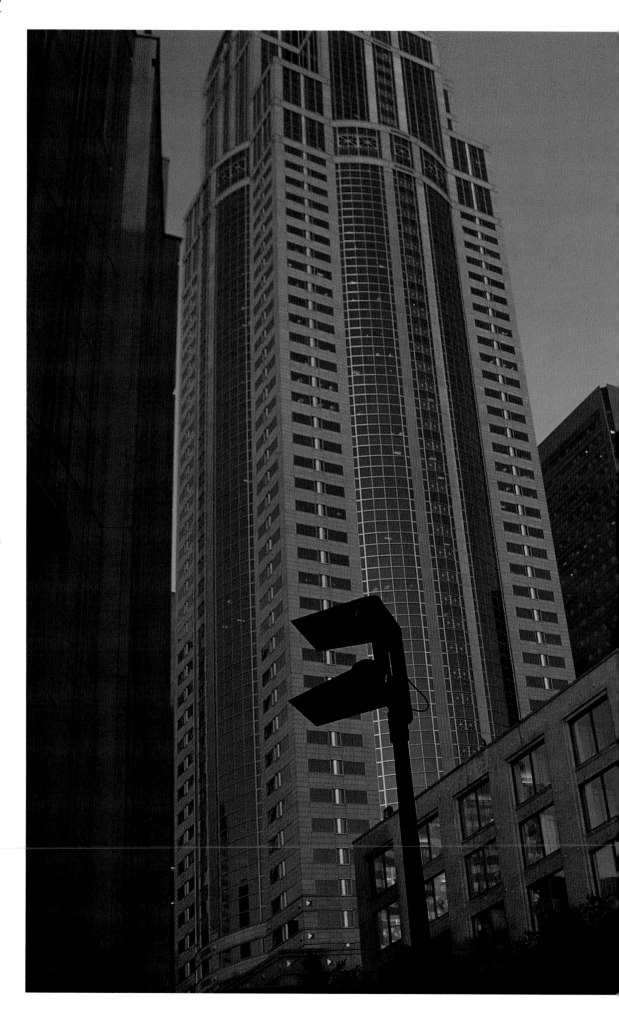

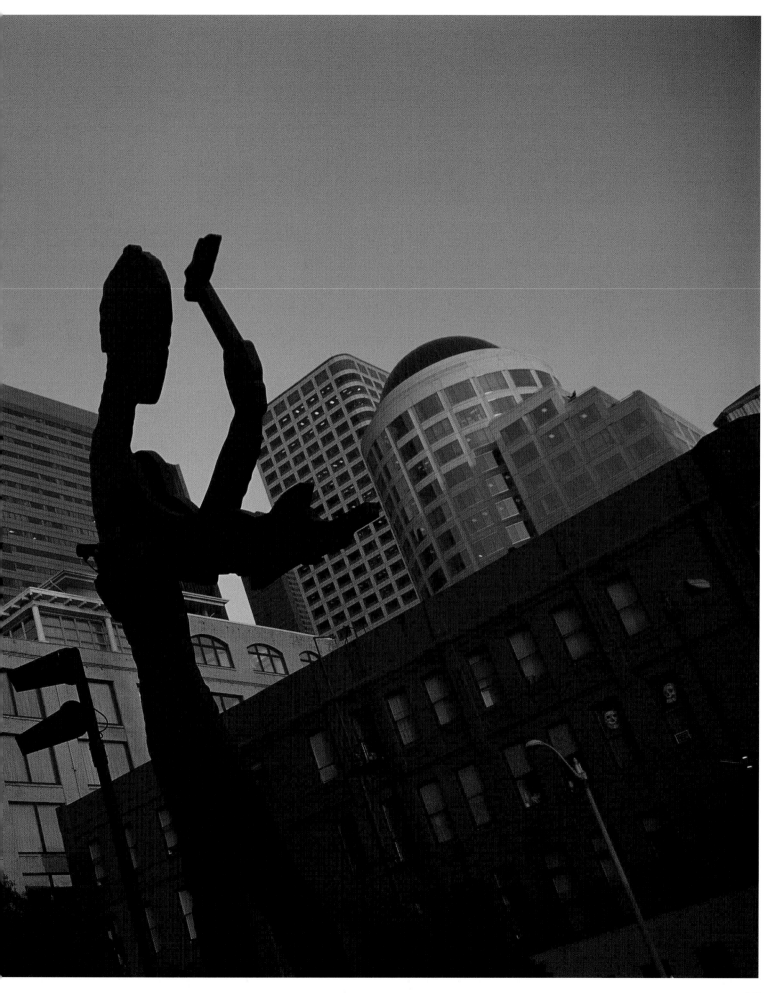

▲ A commuter waits for her ride inside Columbia Seafirst Center, the seventy-six-story tower that caps Seattle's skyline, before setting out into some of the nation's thickest traffic. ▶ *Clockwise from top left:* One stop, at Third Avenue and Madison, on a tour of a city rich in public art. When it opened in 1984, Columbia Center (viewed here from Seattle's International District) reclaimed a distinction that the ornate Smith Tower *(lower left)* first won for Seattle in 1914, when *it* was the tallest building in the West. Recreational Equipment Incorporated, Seattle's legendary outdoor-outfitting co-op, even provides a pinnacle for climbers to practice on.

16

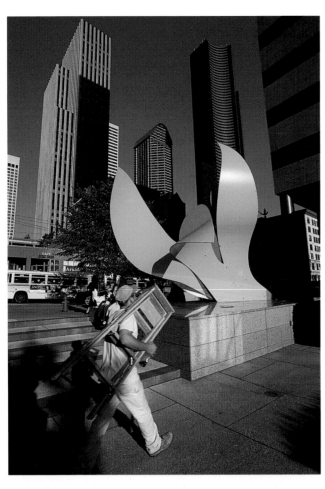

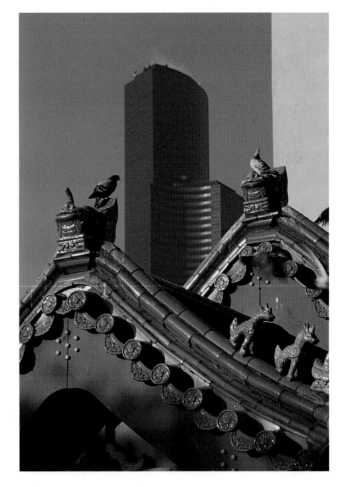

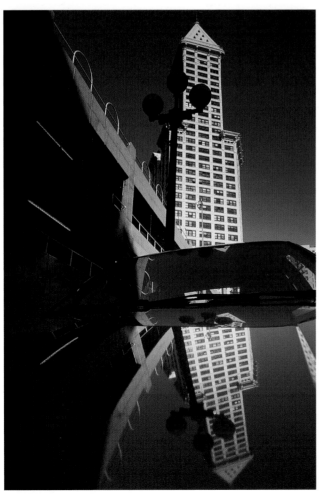

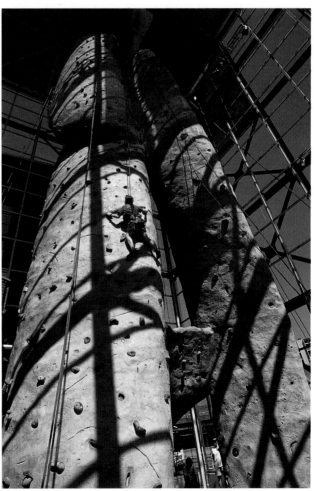

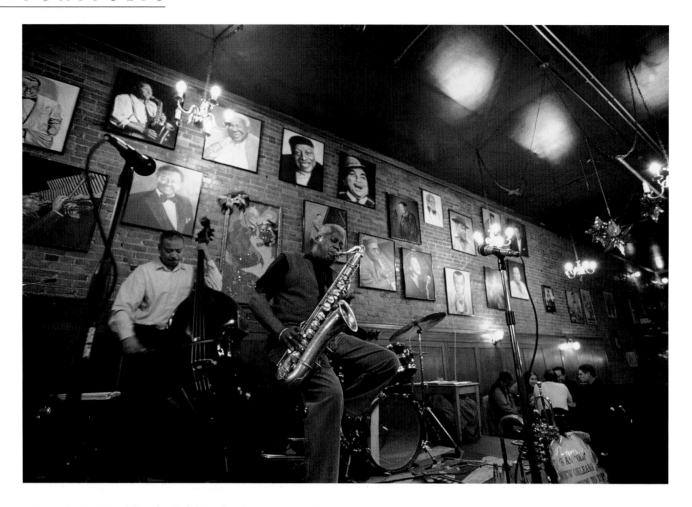

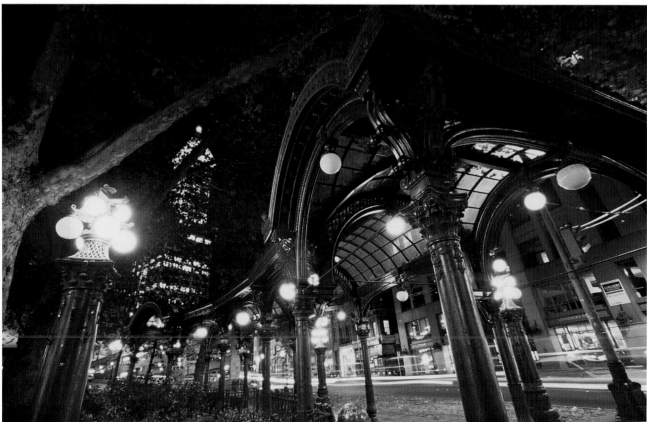

▲ ▲ Floyd Standifer, a stalwart of Seattle's rich jazz legacy, blows at the New Orleans Cafe in Pioneer Square, the center of the city's nightlife and gallery scene. ▲ The city's old crossroads was this pergola at the heart of Pioneer Square. This historic district was saved from demolition first by neglect, then by activists and tax credits. ► Holiday lights twinkle at Westlake Park, downtown Seattle's current crossroads.

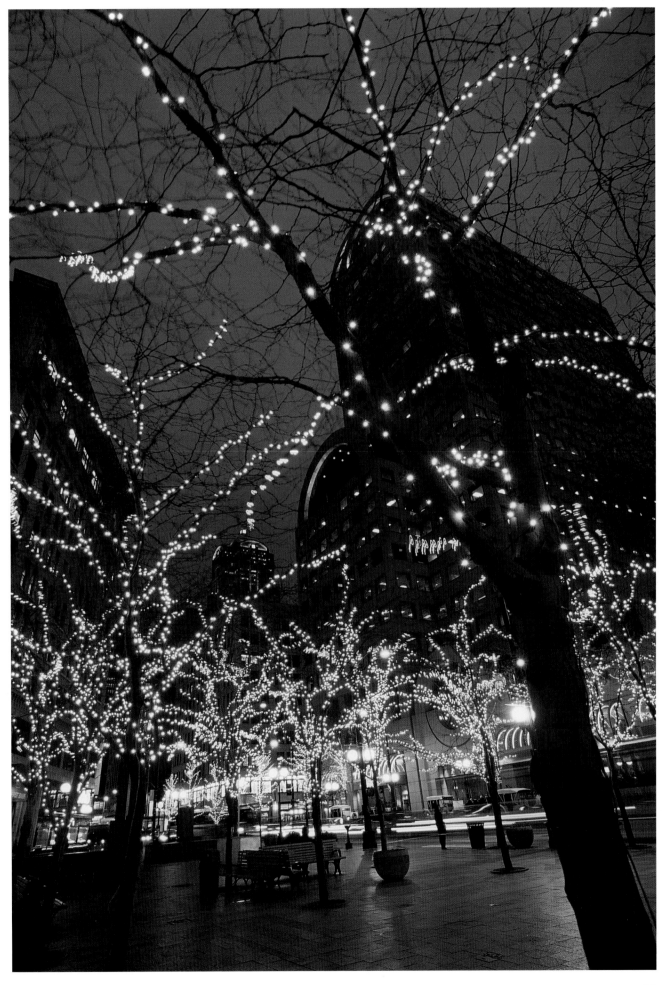

◄ The sawmills and fish-packing wharves of downtown's working waterfront long ago gave way to shipping docks, then to restaurants, tourist shops, an aquarium, and a conference center. Here's the most relaxing way to view it.

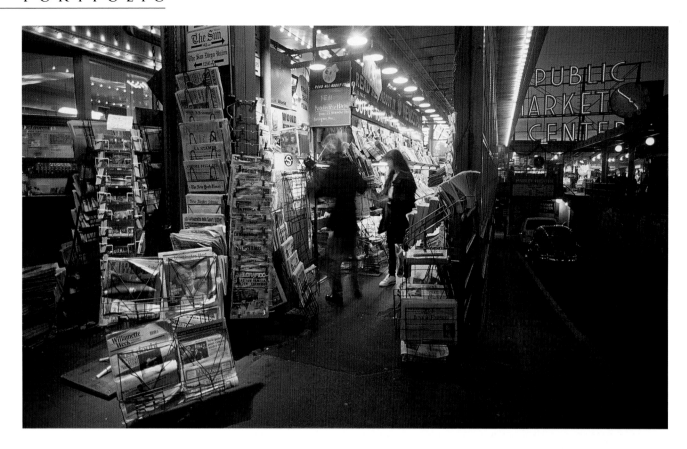

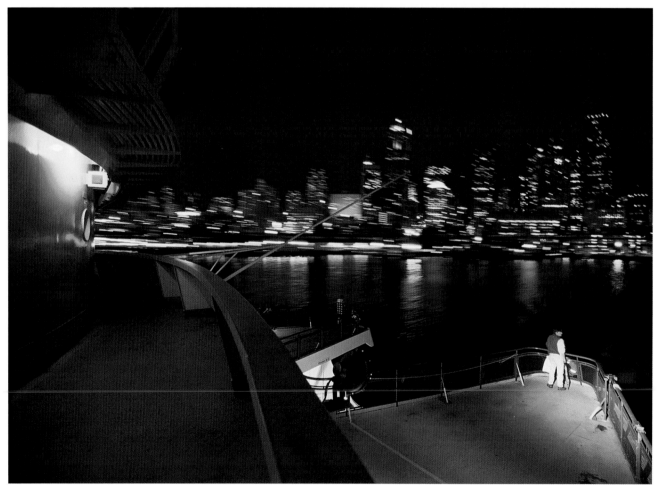

▲▲ People from all over the world get their hometown papers at Read All About It in the Pike Place Market. ▲ The downtown view from a state ferry's "picklefork" deck is the best scenic bargain west of Staten Island. ▶ Amtrak connects Seattle's King Street Station with cities to the south and north, and affords passengers great Puget Sound views; Columbia Center rises behind.

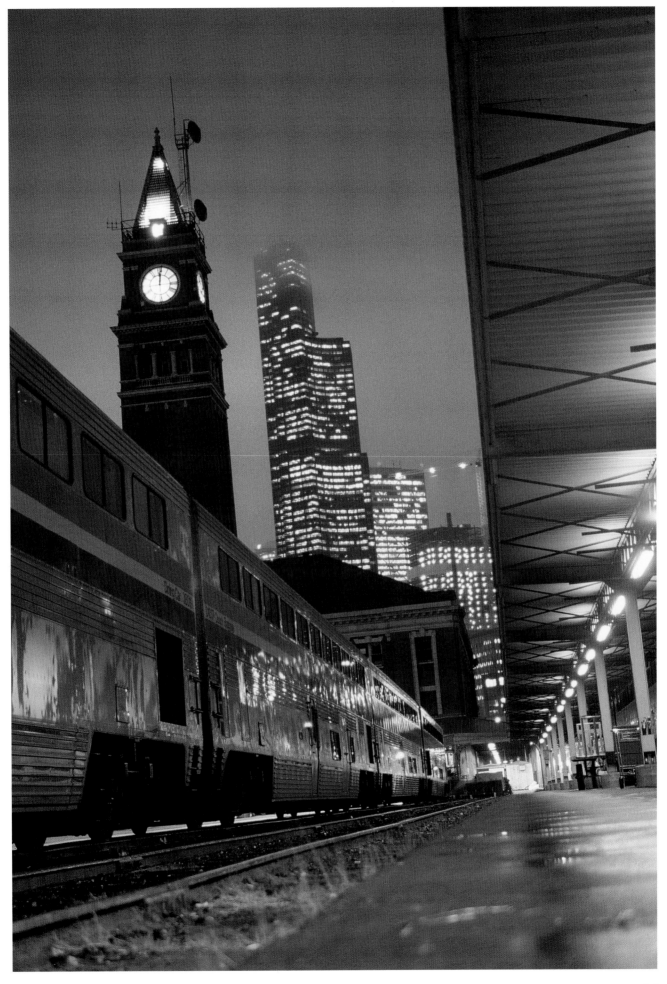

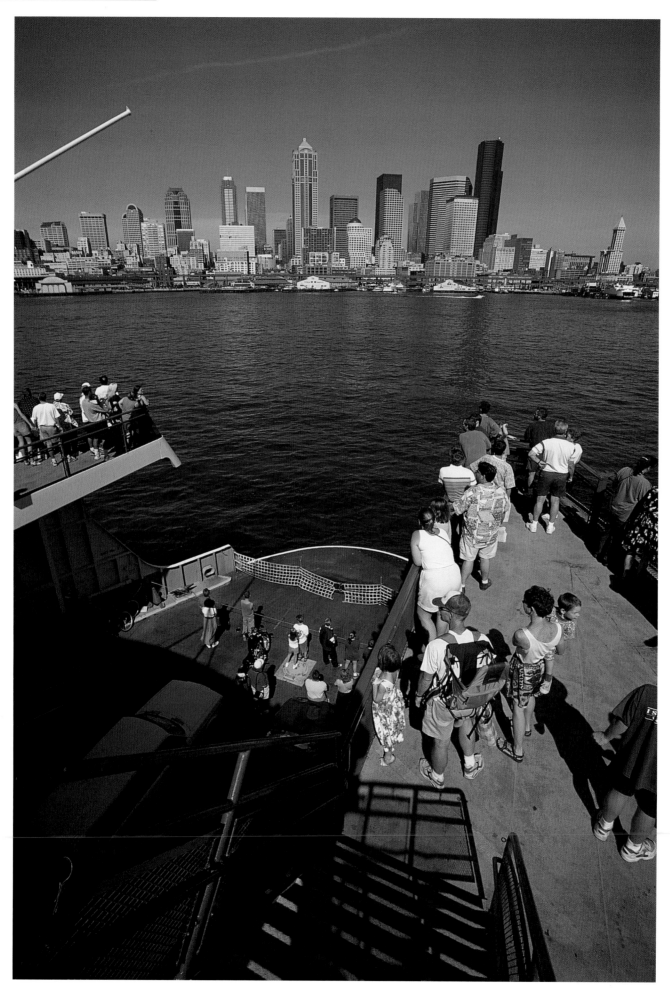

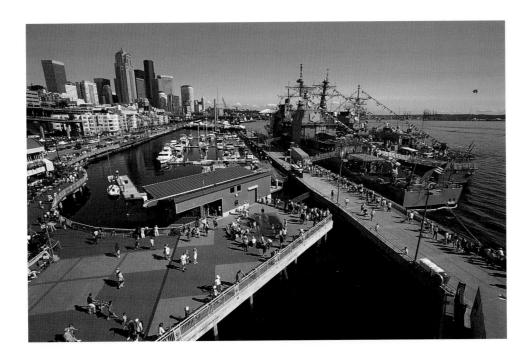

◄◄ In a sunny summer on the Sound, a ferry ride can seem like a trip to the beach.
◄ The Navy comes ashore during Fleet Week to meet and greet at the Bell Harbor Conference Center in the run-up to Seattle's Seafair festival—a great, goofy August extravaganza of pirates, parades, hydrofoil races, and general revelry.
▼ What sport suits a seafaring city? Tugboat races, held off Seattle's waterfront in May (and in Olympia on Labor Day weekend).

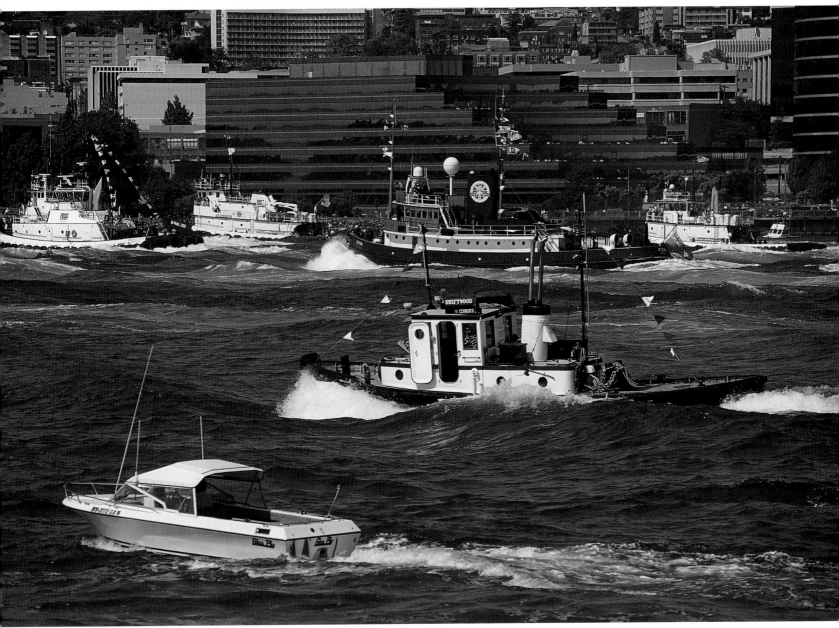

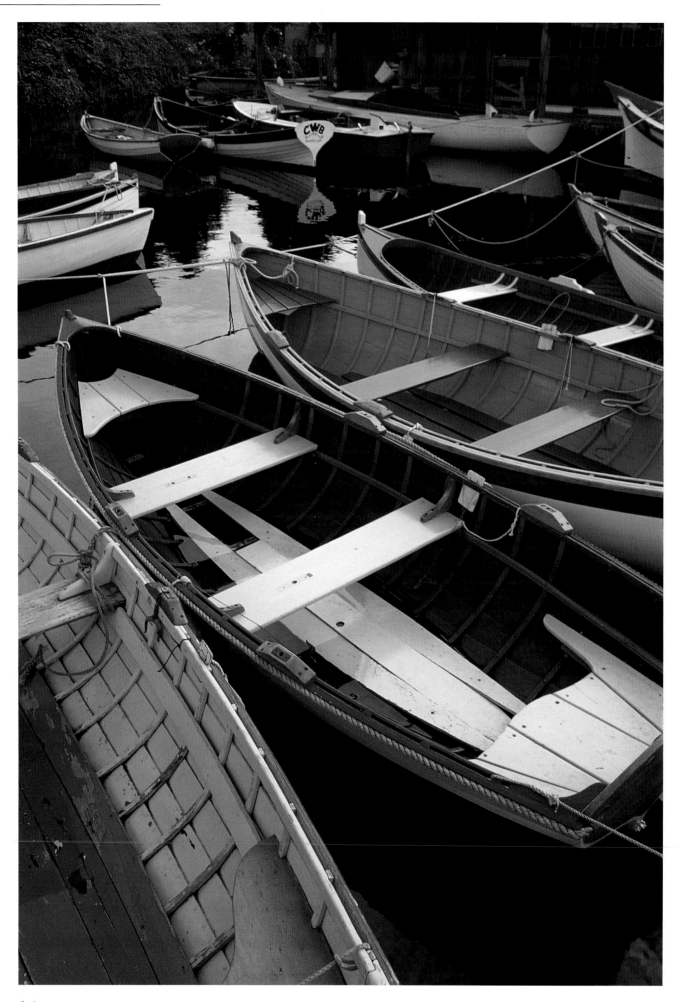

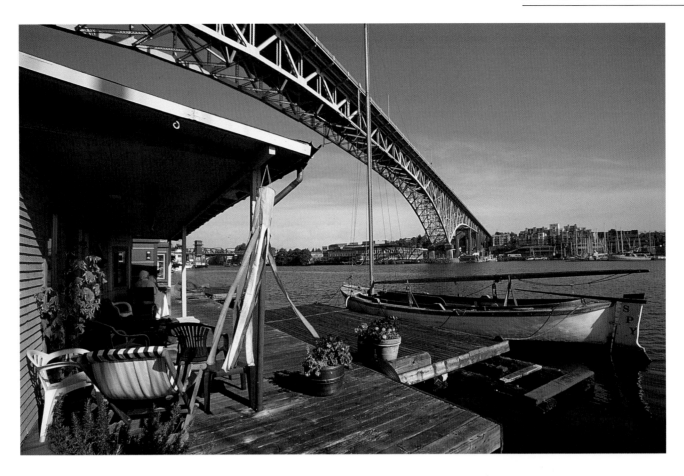

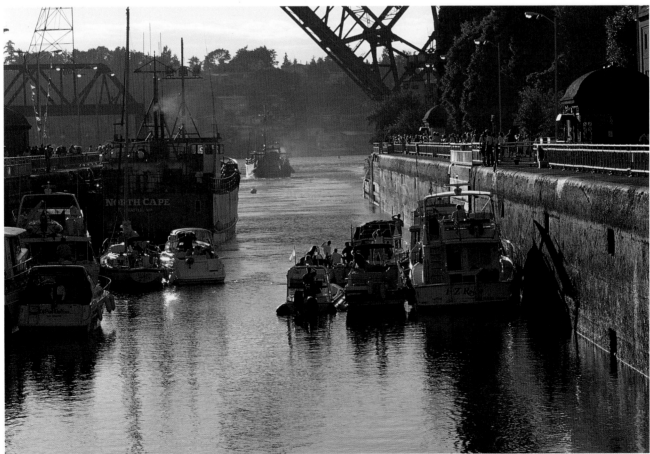

◄ A well-planked rental dinghy and a soothing escape await lunch-hour rowers at Lake Union's Center for Wooden Boats. ▲ ▲ For the lucky
few who can secure moorage on Lake Union, life is a houseboat—even if it's under Seattle's own George Washington (a.k.a. Aurora) Bridge.
▲ Boats travel abovewater and salmon below at the Hiram L. Chittenden Locks, joining Lake Union to the Sound.

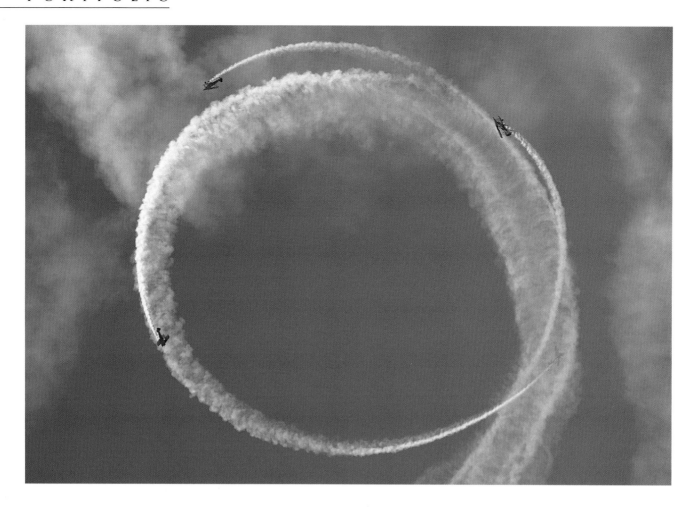

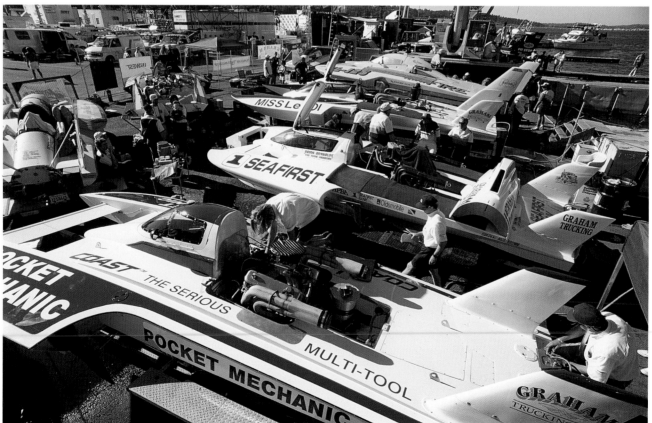

▲ ▲ The Red Baron Stearman Squadron performs above the hydroplane race course during Seafair. ▲ Thunder boats get some last-minute tuning in the Stan Sayres Hydro Pits on Lake Washington, just before the Seafair showdown. ▶ Kenmore Air Harbor on Lake Washington, the world's largest floatplane operator, is home to about seventy-five seaplanes at its base on Lake Washington.

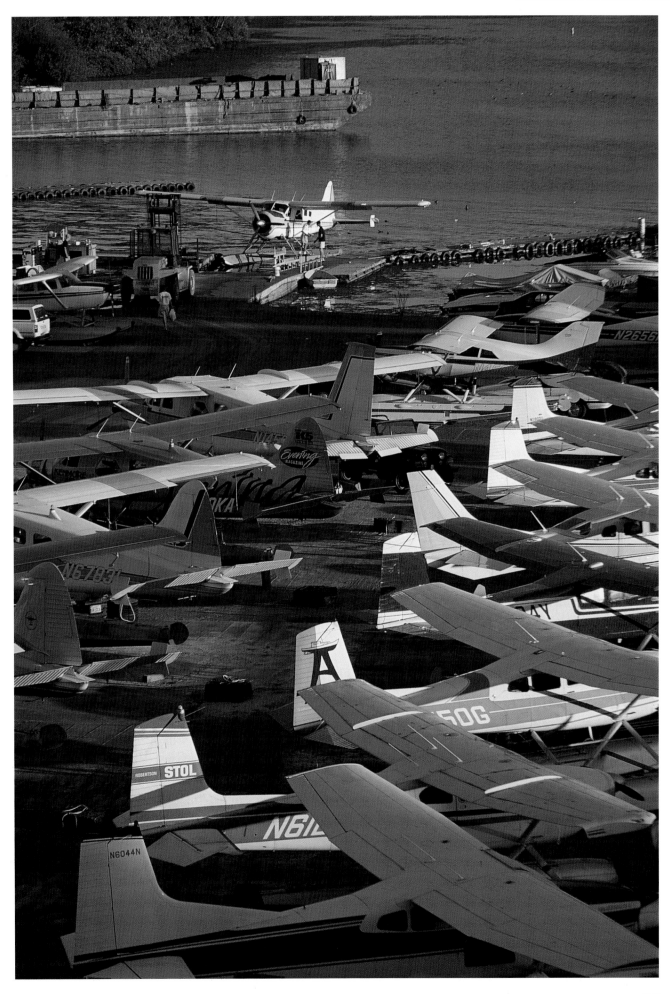

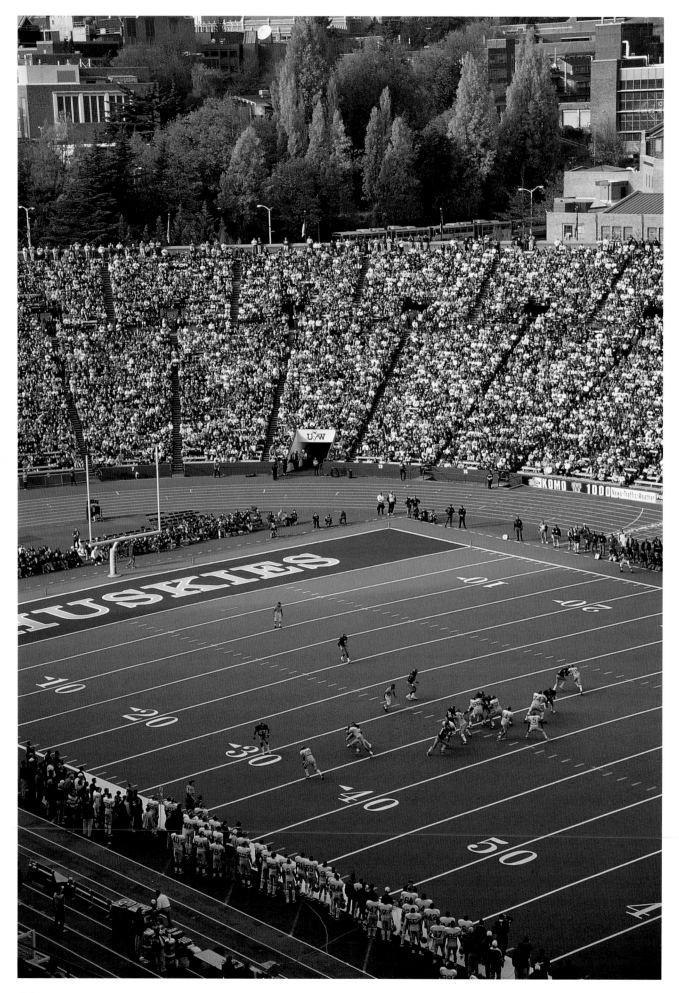

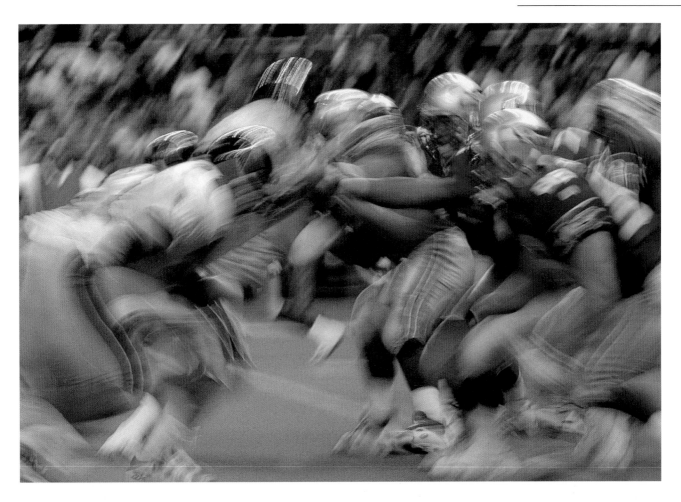

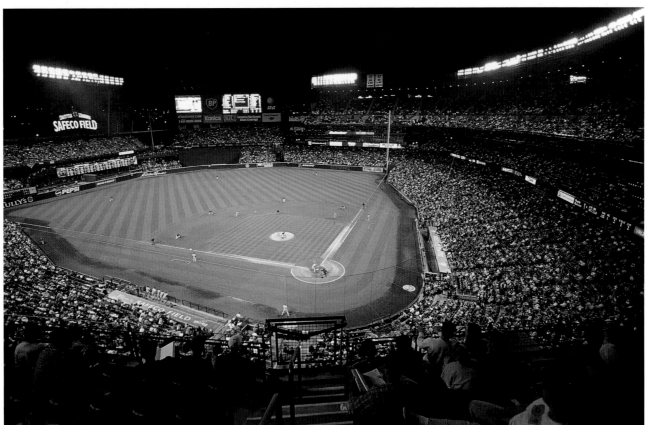

◄ The "Dawgs" do battle in the University of Washington's Husky Stadium, with broad lake and soaring mountain views. ▲▲ The NFL Seahawks fend off Atlanta's defensive line in the 1976-vintage Kingdome, soon to be replaced with a new outdoor stadium. ▲ The American League's Mariners strut in their new SoDo-district stadium; its public funding was controversial, but its design is a homer.

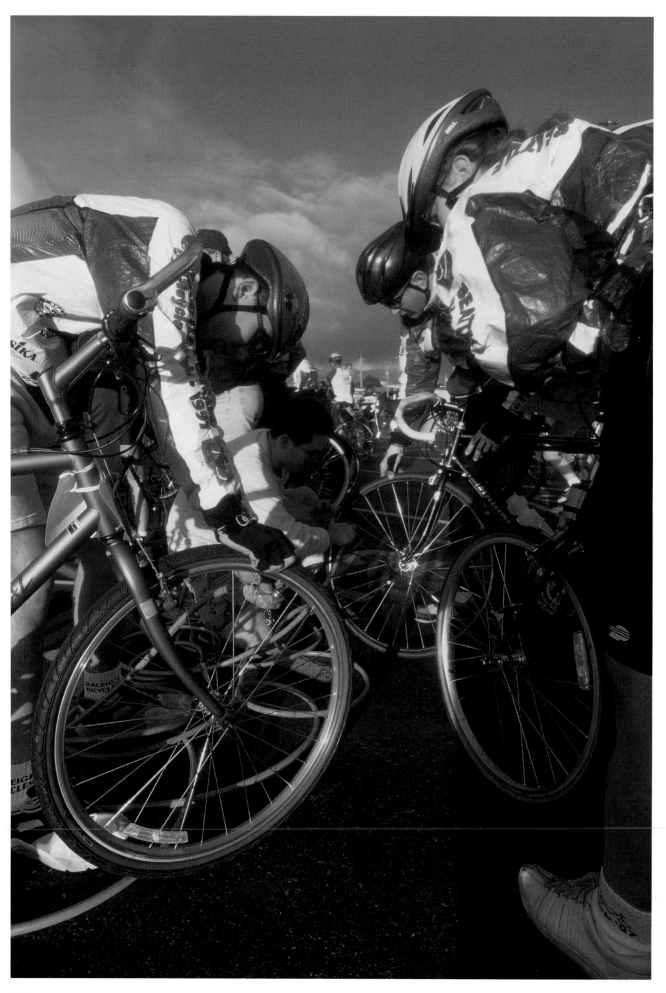

◄ Riders in the July STP (Seattle to Portland) bicycle classic pump up before setting out. Despite hills and rain, and thanks to popular enthusiasm and civic support, Seattle is a bicycling mecca. ► *Taiko* drummers meld power and precision at the Japanese community's *Bon Odori* festival. ▼ Richard Beyer's *Waiting for the Interurban* recalls the streetcars that once rolled across the Fremont Bridge. It's a sculpture cherished by Seattleites, who often deck it with banners and balloons to celebrate holidays, birthdays, and the passing seasons.

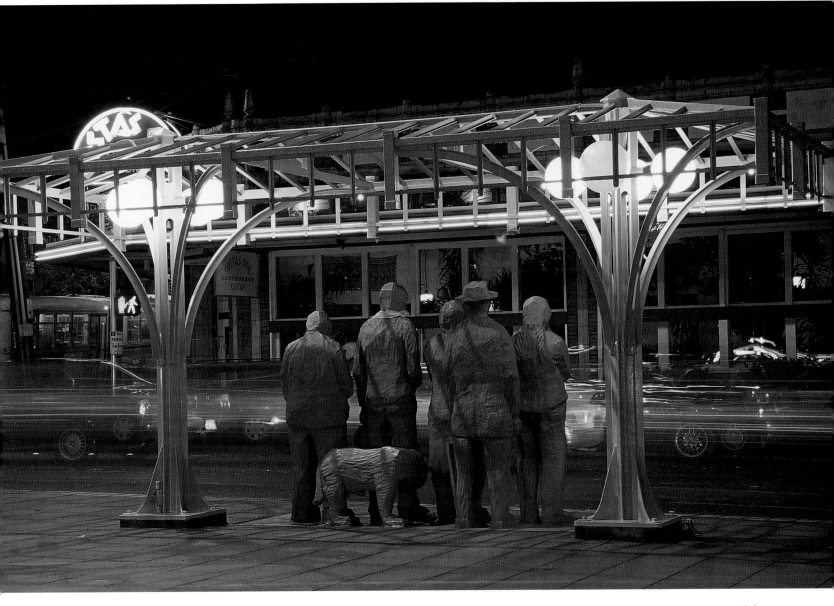

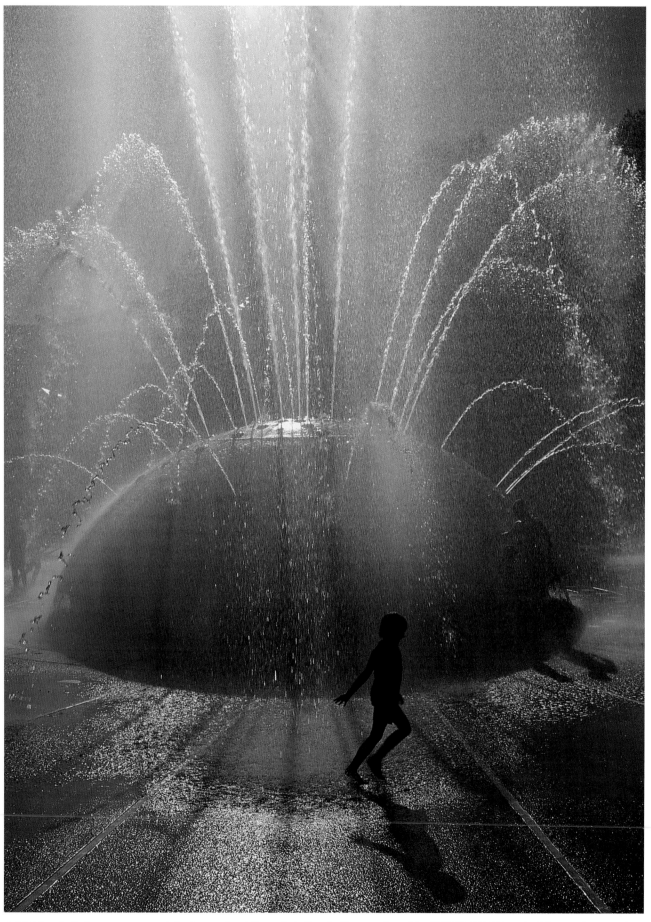

▲ Children frolic in summer around the International Fountain in Seattle Center—site of the 1962 World's Fair and of the popular annual Northwest Folklife and Bumbershoot festivals. ▶ The youngest fiddler at Constitution Days in Ballard, a venerable fishing port and Scandinavian enclave that's rapidly gentrifying.

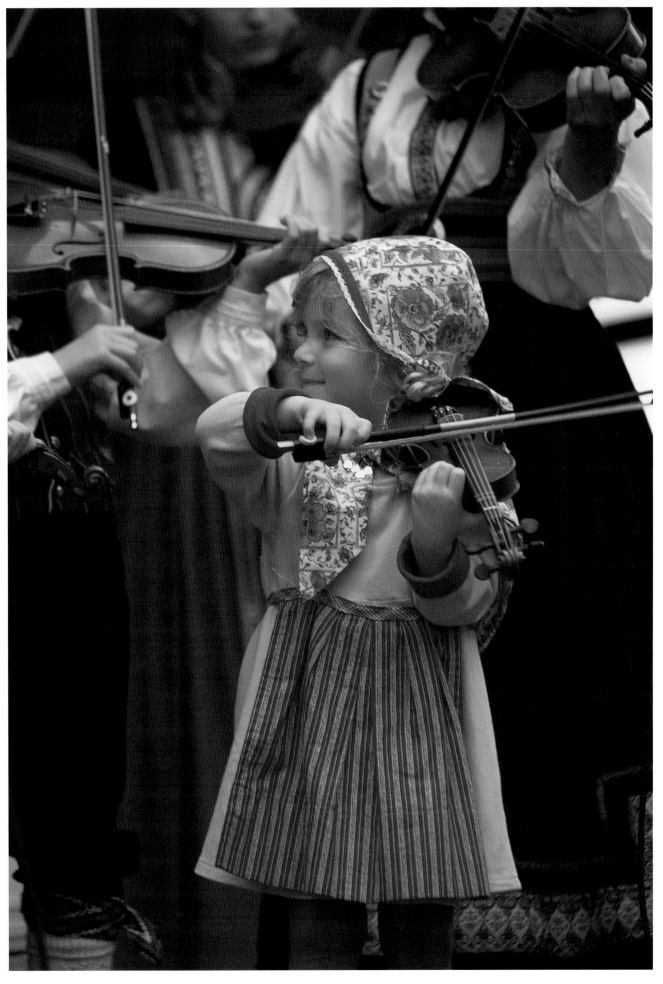

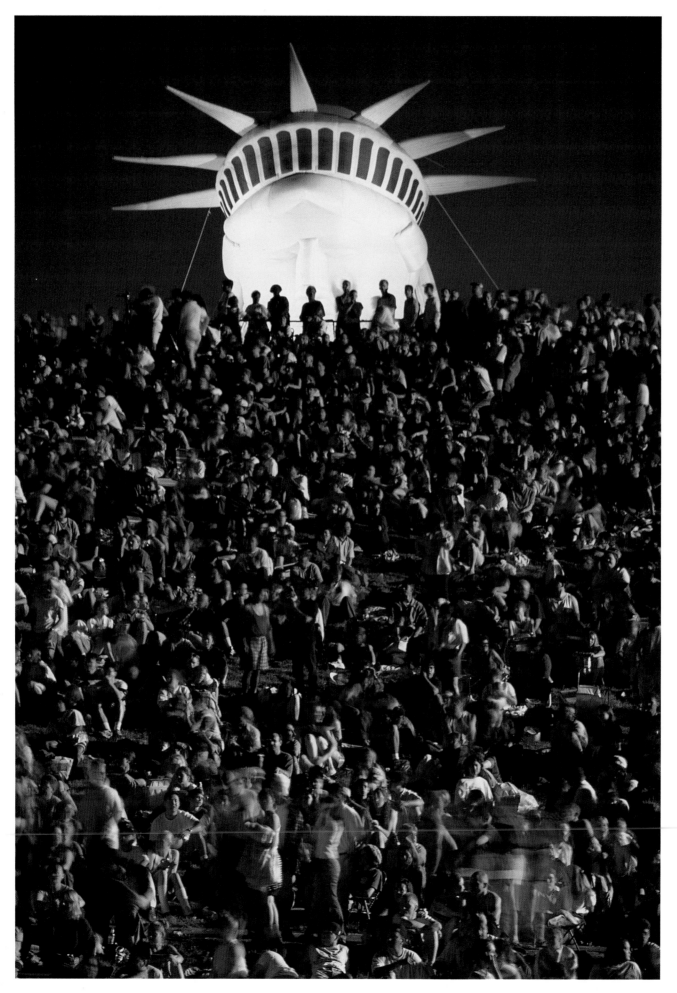

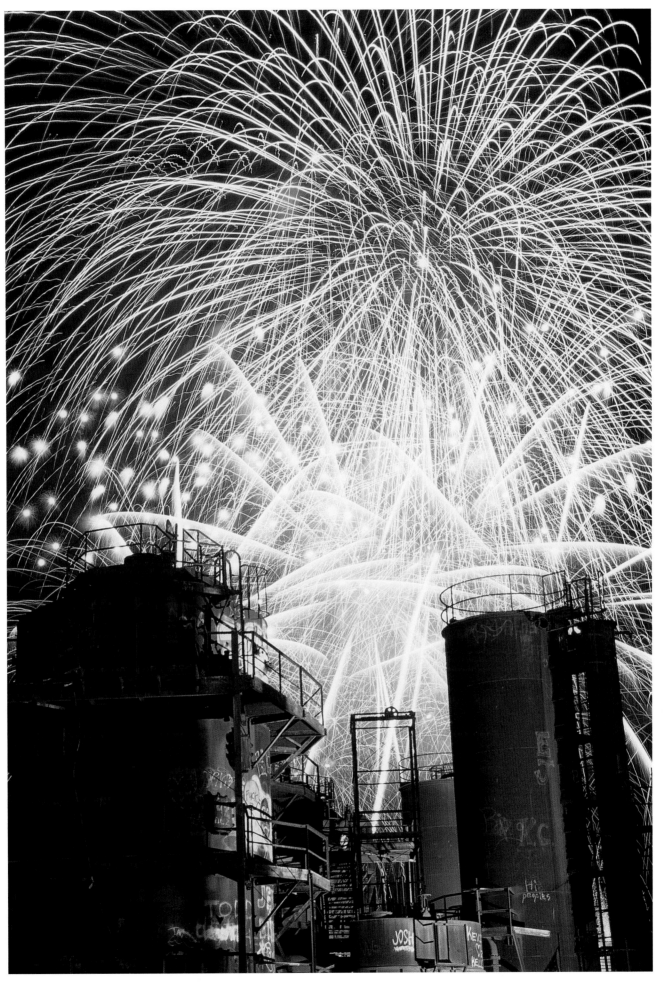

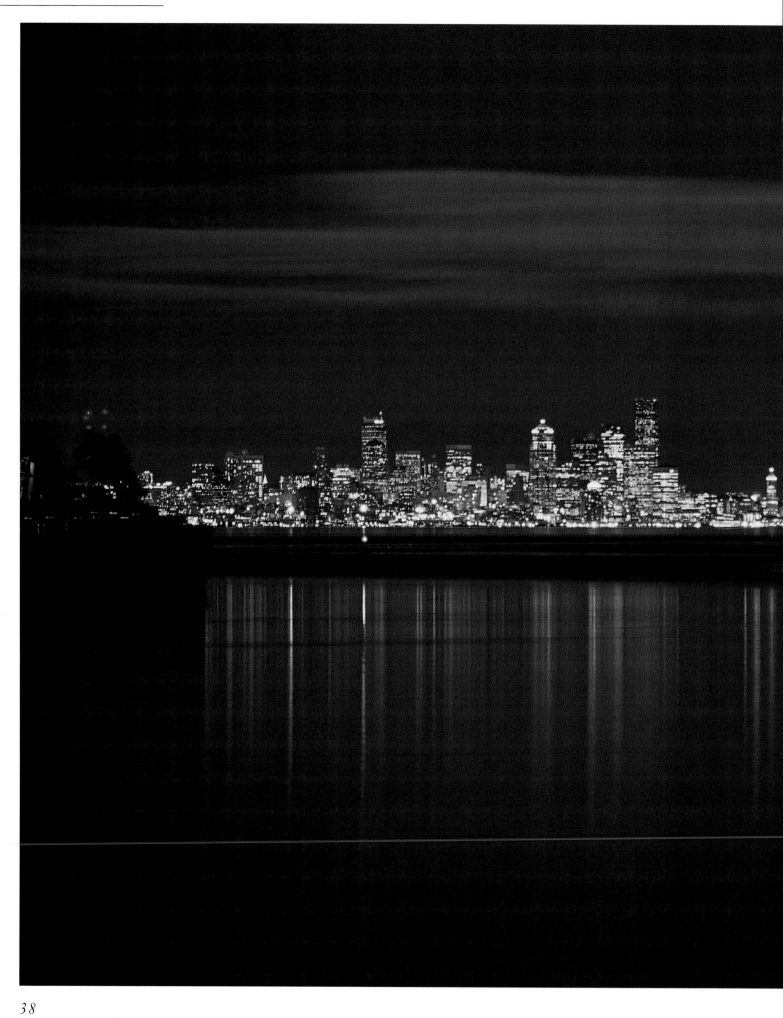

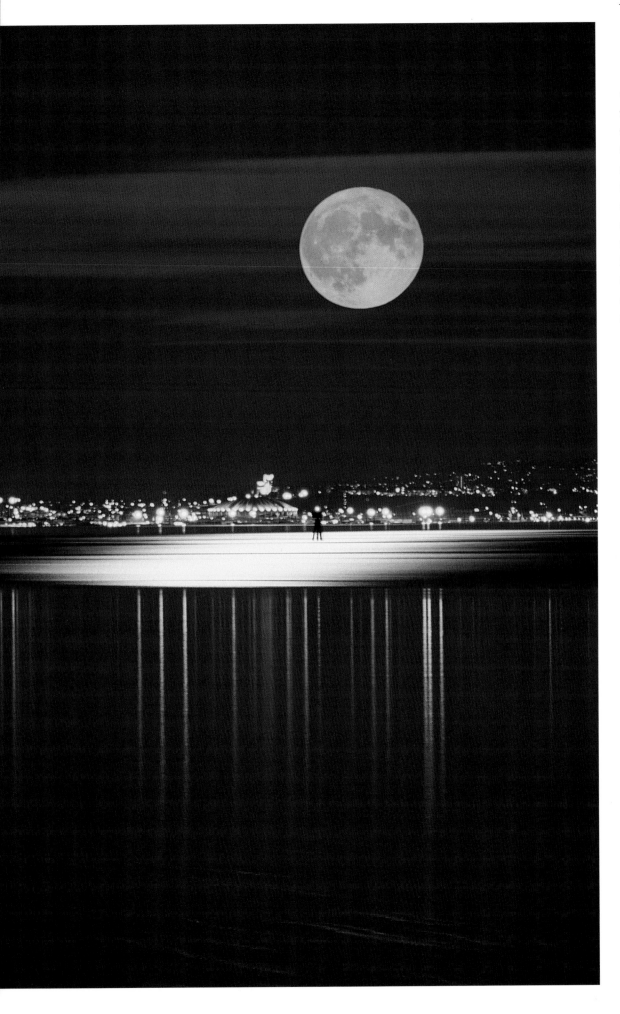

◄ ◄ *Overleaf:* Liberty rises and the rockets glare above Gasworks Park, an abandoned industrial waste site that's now a popular lakeshore park, an icon of Seattle's recycling spirit—and fireworks central on the Fourth of July. ◄ Yes, the sky *does* clear sometimes here—and the moon rises boldly above Seattle's skyline, as viewed near the Winslow docks on Bainbridge Island.

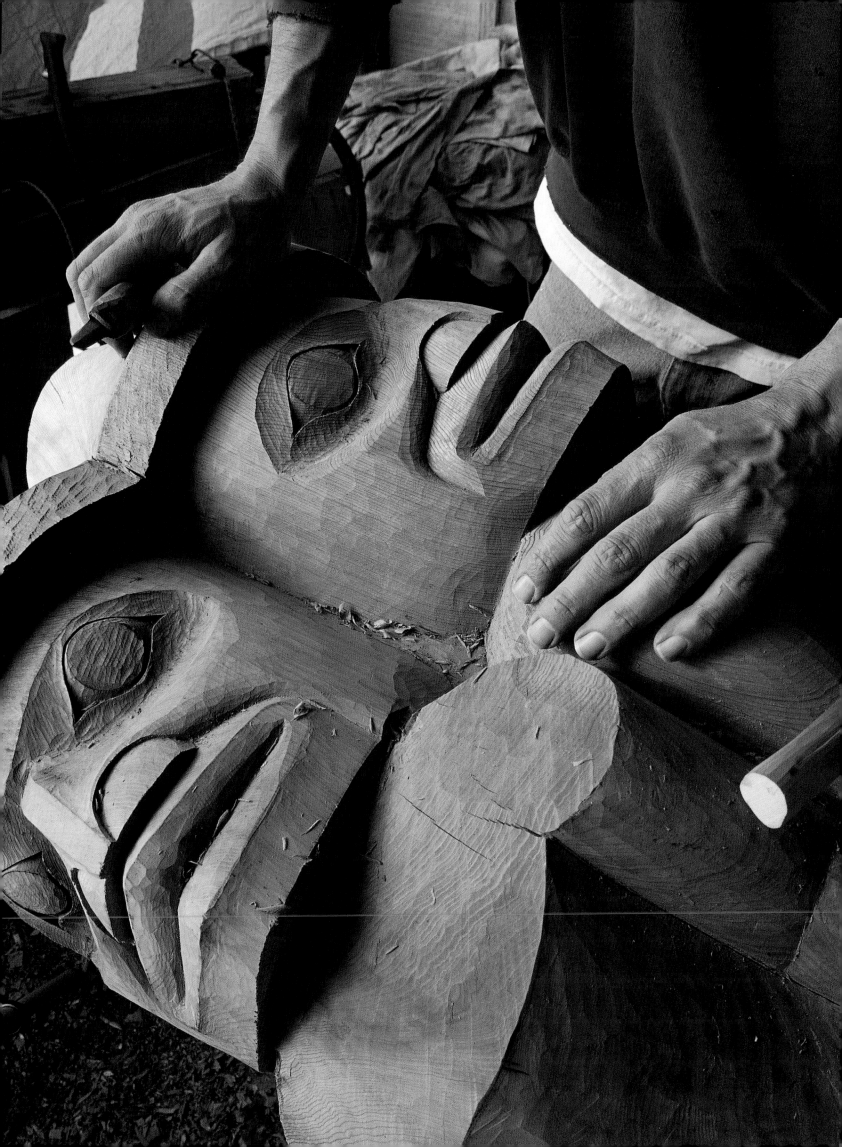

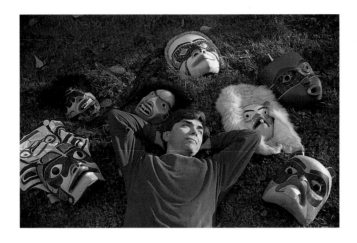

THE SEAWOLF

▪

◄ David Boxley, a Tsimshian carver from Alaska who now lives near Hansville on the Kitsap Peninsula west of the Sound, works on a new totem pole. ▲ Boxley rests among masks he's created. Native traditions and Native artists still move up and down the coast.

Here is one way the story goes, though like all such tales it is told in many ways. Once there was a man, a sort of Native American Rip Van Winkle, who seemed a hopeless slacker, always lost in reverie. His mother-in-law harped on him to get out and catch fish, kill game, cut wood—to do the things a man should do. Finally, weary of the nagging, he set out to prove he wasn't such a layabout after all. He snuck off to a fatal shore, now abandoned, where no one went because those who did disappeared. There he built a giant trap over the water out of a huge cedar trunk split for part of its length and propped open with an alderwood pole. Above this opening he hung two fat fish. The water roiled and up popped the *Wasgo*, the giant Seawolf, the mightiest hunter of the deep (and the most fearsome figure on the Native artists' carved poles). The slacker-turned-overachiever jerked out the alder pole and the split log snapped shut, trapping the Seawolf, which our hero then slew with his mussel-shell spear. He skinned it, wrapped himself in its hide—and became the Seawolf himself. Down he went into the sea, hunting seals, salmon, and even orcas.

As Bill Reid and Robert Bringhurst tell it in *The Raven Steals the Light*, the nagging mother-in-law finally faints and dies when her son-in-law the Wasgo brings *three* killer whales up from the deep. In the tale's more common version, the Seawolf-man himself perishes upon completing this feat.

THE WATER ROILED AND UP POPPED THE *WASGO*, THE GIANT SEAWOLF, THE MIGHTIEST HUNTER OF THE DEEP.

That at least is how the story was handed down by the Haida people of British Columbia's Queen Charlotte Islands, rather than the Salish-speakers who dwelt along the inlets and estuaries of Puget Sound. But it is a tale with many variations and counterparts: mermen, lazy sons-in-law, and sea-conquering heroes in borrowed skins are stock figures of Native American mythologies. The Quileute of the Olympic Peninsula told of a hunter who put on the skin of a seal he had killed, swam with the seals, and taught them how to avoid hunters. Historian David Buerge recounts that those who dwelt around what's now Seattle told of a *Skaitaw*, a long-haired being who lurked at the bottom of the Black River, Lake Washington's old outlet to the Sound. The Skaitaw granted those who dared dive down and wrestle with him the knack of getting rich.

It's likely the Seawolf story traveled here, along the waterborne routes of trade and war that linked the coastal peoples. It resonates as though it were *our* story—an eerie allegory, perhaps even a premonition, of our own latter-day lives upon the inland sea. In a region lately turned upside-down by runaway growth, it speaks to both the plenty and the peril we find along these rich and murky waters, and the greater peril that we bring to them. The man-who-becomes-Seawolf is a patron saint of all the generations—from the first fish-catchers and clamdiggers to the nineteenth century timber barons and current generation of precocious cyber-tycoons—who've found outlandish wealth on these shores.

And he starts out as an underachieving dropout, as befits the region that, during the grunge-rock heyday of the early 1990s, became the world capital of the slacker ethos. Suddenly ne'er-do-wells in torn jeans were international rock stars. And their nerdy cousins, the computer geeks, were billionaire software and Internet entrepreneurs. The hero of the story is even more their precursor: a scorned outsider who secretly invents a new technology that harnesses an undreamed-of power and brings him wealth (back when wealth was measured in seals and whales) beyond all imagining. The generational twist, the way the young fellow confounds his elders, suits a region that's still in a perpetual state of frontier ferment, where twenty-four-year-old hackers become millionaires overnight and rebels and malcontents still come to reinvent themselves and the world.

Most important, our hero finds his wealth, and the power that enables him to seize it, in the sea—just as this region's celebrated wealth, its beauty and delight and its very identity, all trace back to the Sound.

THE SEAWOLF-MAN IS A PATRON SAINT OF ALL THE GENERATIONS—FROM THE FIRST FISH-CATCHERS AND CLAMDIGGERS TO THE NINETEENTH-CENTURY TIMBER BARONS AND THE CURRENT GENERATION OF PRECOCIOUS CYBER-TYCOONS—WHO'VE FOUND OUTLANDISH WEALTH ON THESE SHORES.

MARE NOSTRUM

.

The ancient Romans, who knew better than anyone how an inland sea can tie a civilization together, called the Mediterranean *mare nostrum*—"our sea," the sea at the center of our world, our lives, and our hearts. The sea that feeds and enriches us, that contains us and frees us.

Shelves are lined with tomes on the ways the Mediterranean has shaped the peoples and cultures along its shore; such is the notice a sea gets after five thousand years of recorded history. Few pay such homage to Puget Sound, a much smaller and, both geologically and historically, younger sea. For all Seattle's recent profusion of chic Italian restaurants, who would think to compare the mist-shrouded Sound to Homer's sun-dappled, wine-dark Mediterranean?

But early visitors from back East, marveling at the Sound's scenic and practical riches, leapt to the comparison. Among them was Thomas Somerville, an assistant to Secretary of State William Seward—the man who, by negotiating the U.S. purchase of Alaska, did more than anyone to turn a backwater lumber port named Seattle into a full-fledged, booming city. In an 1870 article for *Harper's*, Somerville praised the Sound as "the Mediterranean of the Pacific." Thirty-nine years later, Tacoma's *Sunday Tribune* called it "the great water roadstead, the Mediterranean of America." Presumptuous though the label sounded, it was not merely fanciful. With its cool, damp winters and warm, dry summers, the Sound

▲ The Hotel de Haro at Roche Harbor on San Juan Island was built in 1886 to house workers at the local lime pits. Now it's a favorite retreat for boaters and others seeking a dose of island serenity.

FOR ALL SEATTLE'S CHIC ITALIAN RESTAURANTS, WHO WOULD THINK TO COMPARE THE MIST-SHROUDED SOUND TO HOMER'S SUN-DAPPLED MEDITERRANEAN?

lies at the north end of one of the few littorals (others are in Chile, Australia, and South Africa) with a bona fide Mediterranean climate. Like the Romans' *mare nostrum*, it unites and defines a region, a sensibility, even a culture in the making.

Consider how every other attempt to draw the outline of a "region" on this part of the planet proves arbitrary and inadequate, even absurd. "The Pacific Northwest" is an empty phrase: What do the stark steppes of southeastern Idaho, inhabited by Mormons, jackrabbits, and a few Jack Mormons, share with rocky, New Age–tinged Orcas Island? What do the Montana Rockies have to do with the Pacific, except that their waters eventually drain into it if they manage to cross the deserts along the way?

"Washington State" is a bad marriage and a geographic oxymoron, as any Washington legislator brave enough to admit it can tell you. East of the Cascade Mountains lie wheat fields, rodeos, Republicans, and California-style, irrigation-dependent agribusiness. West of the Cascade Curtain are trees and fish (though fewer of both, and smaller, than before), jet and software makers, Democrats and whale-huggers and hemp liberationists. It was the wet west side, where most of the people live and most of the noise gets made, that led James Farley, Franklin Roosevelt's campaign manager, to note "the forty seven states and the Soviet of Washington." The unusual career path of Congressman Jay Inslee, who as of this writing represents the Seattle suburbs of Washington's First District, demonstrates the difference. In 1992, the year another Democrat won the White House, Inslee won a congressional seat east of the mountains. Two years later his constituents returned to form and dumped him for a rock-ribbed conservative Republican. Inslee relocated to Bainbridge Island, across the Sound from Seattle, and won a new seat there. He'd learned where the Cascade Curtain falls. East is East and West is Puget Sound Country, and rarely the twain shall meet.

The first Puget Sounders understood well what that curtain meant, and how a rain shadow works. In *Indian Legends of the Pacific Northwest*, Ella H. Clark records the traditional explanation of the mountains' and Sound's origins. Long ago, the people who lived to the east persuaded Ocean to send them his daughters Cloud and Rain, so that their land might bloom. Then they refused to let the daughters go. Ocean begged the Great Spirit to return his daughters and punish the eastern people for their greed. So the Great Spirit threw up a wall of mountains, the Cascades, to keep Cloud and Rain near the Ocean. The trench he dug to form the mountains filled with water, becoming what we call "Puget Sound."

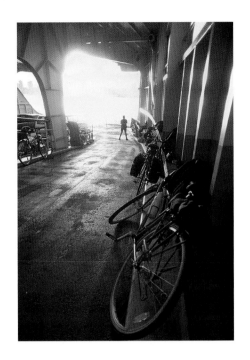

WHULGE

.

But what do we mean when we say "Puget Sound"? It is at once the most present and elusive of geographic entities; we speak of it constantly, but cannot even agree where it starts and ends. Is it the entire inland waterway, or web of waterways, from Totten Inlet to Lummi Bay and the San Juans? I once heard someone who often traveled these channels say that "Puget Sound" should signify any waters crossed by the local ferries. Would that include all those crossed by the Alaska ferries that depart from Bellingham? Advertising copywriters and the yakking heads of radio and television have even taken to referring to the entire region within their airwaves' reach as "the Puget Sound," a crude shorthand for "the Puget Sound region."

Captain George Vancouver of His Majesty's Navy had something very different in mind in 1792, when he undertook the first thoroughgoing European exploration of these waters and gave them the names we use (though not as he intended) today. Vancouver dubbed the inland sea that lay south and east of the Strait of Juan de Fuca "Admiralty Inlet," and called the bigger sea that stretched north, past Whidbey, San Juan, and Vancouver Islands, "the Gulph of Georgia." Fearing to take his big sloop *Discovery* into the narrow passage east of Vashon Island and even narrower passages farther south, Vancouver dispatched Lieutenant Peter Puget in the *Discovery*'s launch to chart them.

▲ On an early morning ferry to Seattle, an STP biker awaits the long pedal to Portland. Even when the cars back up at the ferry docks, bicyclists always get aboard.

I once heard someone who often traveled these channels say that "Puget Sound" should signify any waters crossed by the local ferries.

"By our joint efforts, we had completely explored every turning of this extensive inlet," Vancouver wrote, "& to commemorate Mr. Puget's exertions, the south extremity of it I named Puget's Sound." Thus did the region acquire its Francophonic flourish: Puget was a scion of a French Huguenot family that had fled to England.

One would expect a dutiful captain to name the biggest water body he charted after his king (George III) and the next biggest after the admirals above him, and to honor his aide last of all. In the same vein, Vancouver also named the giant peak that loomed over the Sound—er, Inlet—after an admiral, Peter Rainier, who never came anywhere near it—a name that became incongruous when Mount Rainier became U.S. territory, since Rainier was best known for his exploits against the rebels in the American Revolution.

But poetic resonance will out. Almost since Vancouver named it, "Puget Sound" has expanded like a balloon, like America itself, on our mental and literal maps. First, the terms "Admiralty Inlet" and "Puget Sound" traded roles. "Puget Sound," Vancouver's "south extremity," came to signify the entire inland sea south and west of the Strait of Juan de Fuca. And "Admiralty Inlet," originally the whole, became just a part: the channel between the Sound and Strait.

Now the idea of Puget Sound is expanding even further. We speak of a "Puget Sound region" (or, increasingly, "the Puget Sound"), stretching from Cape Flattery, where the Strait of Juan de Fuca meets the open ocean, to Olympia and Shelton at the inland sea's southern reaches, to Point Roberts at the Canadian border, and even to the Canadian delta lands beyond. Thus is the name of an opaque, mysterious, and pristine body of water applied to an agglomeration of land, roads, and people, of growing cities and shrinking forests. Puget Sound becomes Pugetopolis, and the water itself is forgotten.

Every few years frustration at this confused state of nomenclature wells up, and some well-meaning geographer urges that the inland sea receive a more appropriate, Native-derived name. The usual candidate is "The Salish Sea," after the group of languages spoken by the Native dwellers along its shores. But as the redoubtable conservationist and civil-disobedient beachwalker Harvey Manning points out, "Salish Sea" is still a foreign label—worse yet, a label with pretensions of authenticity, like calling Chief Sealth "Seattle." The Salish speakers never called their waterway "the Salish Sea." Better then to use the name they used. And that was . . . *Whulge.*

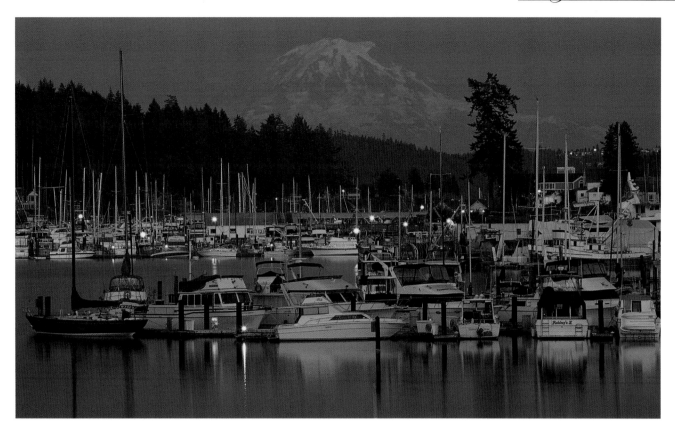

Odd though "Whulge" sounds, it has a warm, embracing, womb-like quality, as befits our Mother Sea. And embracing it isn't just some recent New Age affectation: Theodore Winthrop called the local waters "Whulge" in his 1862 *Canoe and Saddle*. *The Tacoma Sunday Tribune* picked up the term in 1909—and also referred to Mounts Rainier and Baker by their original names, Tacoma and Kulshan. (Tacomans, cherishing their historic rivalry with Seattle and fuming at Seattle's snootiness, have long craved to restore the proper name of their namesake mountain.)

There's always a slight chance that "Mount Tacoma" (or "Tahoma," or "Tacobet"— transcriptions vary) will catch on; Alaska has resumed calling Denali (a.k.a. Mount McKinley) by its original name. But "Whulge" seems a hopeless, though noble, cause. For better or worse, we're stuck with "Puget Sound." Or, rather, stuck on it. It's a name that's acquired the power to conjure rather than describe. The looseness with which we bandy it about does not prove our disconnection from the Sound, but rather our attachment to it—our longing to express an emerging sense of regional identity that we intuit to be inextricably tied to the waters upon which the region has grown. "I don't know the meaning of life, but I love it," E. B. White is said to have declared. We don't know exactly *where* Puget Sound is, but we love it.

▲ Gig Harbor on the Kitsap Peninsula has a few of the 450,000-odd pleasure boats in the state, and what some claim is the best view anywhere of Mount Rainier/Tahoma.

ODD THOUGH "WHULGE" SOUNDS, IT HAS A WARM, EMBRACING, WOMB-LIKE QUALITY, AS BEFITS OUR MOTHER SEA.

DANGEROUS BEAUTY

.

▲ On scenic Chuckanut Drive south of Bellingham, young rocks testify to the region's still-evolving, sometimes violently evolving geology.

Geologically and ecologically, it makes sense to think of a wider expanse than Puget Sound proper. Scientists speak of a broader "Puget Sound basin" comprising all the inland seas below the Fraser River delta and east of Cape Flattery and the Pacific Coast—the Straits of Haro, Rosario, and Juan de Fuca, Puget Sound and Admiralty Inlet, and Hood Canal, America's most perfect fjord—the rivers that feed them, and the lands those rivers drain. All these share common ecosystems and a common—and surprisingly recent—origin.

ON VANCOUVER ISLAND AND THE SAN JUANS, YOU CAN STILL SEE THE COLLISION POINTS— STRIKING JUXTAPOSITIONS OF MISMATCHED ROCK FORMS.

From a psychological view, it's fitting that we should thrash so over where Puget Sound lies and how we fit in with it, when the lands and waters themselves are so new and raw. In mountains as in people, abruptness and rough edges are signs of youth—and this is young country, in geologic and human terms. The American continent has developed much as American society has—from the East, with its worn old Appalachian knobs, westward. One hundred million years ago, the Puget Sound basin and nearly all the rest of what's now Washington State lay under the Pacific Ocean. One by one, *terranes*, mini-continents floating in the earth's unstable crust, slammed into North America, extending the landmass. On Vancouver Island and the San Juans, you can still see the collision points—striking juxtapositions of mismatched rock forms.

The continental plates continued to subduct, scraping over each other and

triggering vast volcanic eruptions from which sheets of lava flowed, pushing the land out into the sea. The terrane that formed the North Cascades and, eventually, the east edge of Puget Sound collided with North America about fifty million years ago, and the Cascades rose over the next few eons. The Olympics, brash upstarts as mountains go, rose just fifteen million years ago. Most of the Cascade volcanoes are only half a million years old, give or take a few millennia; the baby of the family, Mount St. Helens, is about four thousand years old, younger than the pyramids at Giza. Her 1980 eruption was an infant's tantrum.

Puget Sound itself is only about thirteen thousand years old—about as old as the oldest human artifacts found in North America and considerably younger than the art that early humans left in caves in Europe, Africa, and Australia. The great Fraser Glaciation, the force that would form the Sound and surrounding lands, began about one hundred thousand years ago—a blink of the geologic eye. It reached its peak eighteen thousand years ago, when Seattle was buried more than half a mile deep in ice and Bellingham a mile deep. The ice weighed so much it literally stretched the earth's crust, pushing the surface down four hundred feet at the Sound's center.

Then, about fourteen thousand years ago, the ice began retreating, carving out channels and valleys, plopping down hills and islands, and leaving a vast freshwater lake in its wake. Eight hundred years later, it vacated the Strait of Juan de Fuca, and seawater rushed in and displaced the lake. Puget Sound was born.

It is humbling and useful to remember the sort of cataclysms that formed this land, and that will shake and re-form it again and again. The continental plates are still subducting, and the seismologists say that some day they'll release their pent-up pressures with a jerk that will make California's quakes seem like hula whirls. California's San Andreas Fault shakes more often, hence less violently. Our Seattle Fault builds up to some real doozies. The last really big one, about eleven hundred years ago, sent a tsunami roaring across Puget Sound and raised Seattle's Alki Point twenty-two feet higher.

Meanwhile, Rainier/Tahoma is gathering to an eruption that will likely make St. Helens' 1980 blowout seem like a burp; Tahoma's last burst, two hundred years ago, sent hot mud flowing to Tacoma. But just as the two centuries of European-American history in the Northwest have been blissfully free of megaquakes, it's quite possible nothing big will blow in our lifetimes. Then again, something might.

SEATTLE WAS BURIED MORE THAN HALF A MILE DEEP IN ICE AND BELLINGHAM A MILE DEEP. THE ICE WEIGHED SO MUCH IT LITERALLY STRETCHED THE EARTH'S CRUST, PUSHING THE SURFACE DOWN FOUR HUNDRED FEET AT THE SOUND'S CENTER.

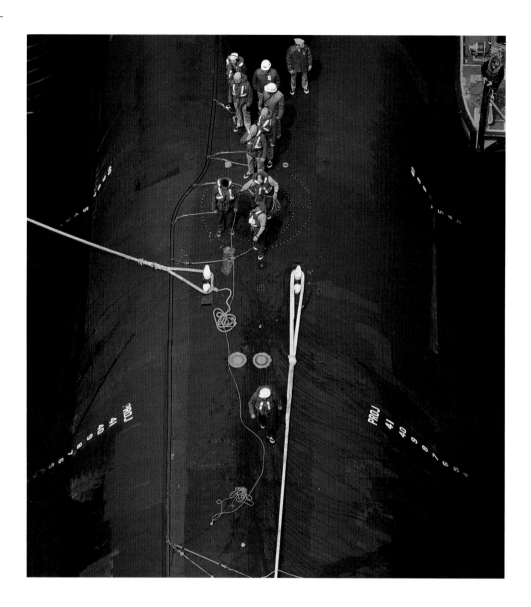

▶ A Trident nuclear submarine, one of the greatest concentrations of destructive power ever assembled, pulls into its berth at Bangor on serene Hood Canal.

Or you might finally achieve the dream of owning your very own waterfront retreat by the Sound, only to watch it slip away in the mudslides that occur on one shore or other every wet winter. That is, unless your dream perch is on the west shore of Hood Canal, the outer Strait of Juan de Fuca, the Chuckanut Hills, or the San Juan Islands—areas that are mostly formed of rock. Otherwise, you're probably on sand or clay that might sink as easily as the glaciers scooped it up. Or worse: The newspaper I write for sits on the third floor of a century-old brick building a block from the downtown waterfront, atop fill dirt laced with sawdust that the early boosters dumped here to turn tideflats into profitable real estate. Outside, I have a peekaboo view of the Sound framed by the Alaska Way Viaduct, the old elevated highway that soars above the waterfront. The right temblor could turn this dirt to jelly and the Viaduct to deadly rubble. On May 2, 1996, that temblor seemed for a moment to have arrived; the floor shook, the walls seemed to ripple, and whoever wasn't too stunned to move dashed for the relative safety

of desks and doorways. Then, having logged a Richter reading of 5.3, the quake passed in the usual way: No harm done, nothing to worry about. We returned to our duties with the special cockiness of those who have just dodged a bullet.

Danger and uncertainty are the spices of life here, where continents meet and worlds still collide. Surrounded by so much dangerous beauty, we learn to appreciate the impermanence of things—and to accept the dangers, if we want to fully enjoy life on these shores. A few years back, I took a hankering to acquire my own little patch of paradise, some wild, secluded waterfront on Vashon Island—back when such retreats could still be had fairly cheap. But despite heart-stopping views and mind-expanding serenity, I passed on one property after another—scared off by ominous geotechnical reports and sodden bluffs that looked like landslides waiting to happen. I recently checked on the waterfront parcels I shied away from buying. They're all still safe and standing, though nearby homes that seemed more solidly anchored have been condemned or even slid into the Sound. I didn't accept the risks, and missed out on paradise.

Sometimes it seems we reenact the contradictions of our landscape in our contradictory "Northwest way of life." Here we sit on one of the more unstable and potentially dangerous parts of the planet—which, day to day, is the most gentle and comfortable of settings. Winter and summer are both mild, if monotonous; snow, sleet, tornadoes, and serious heat and humidity are all rare. We have fewer mosquitoes than many Eastern locales and no hurricanes, blizzards, black widows, poisonous snakes, Lyme-bearing ticks, killer bees, or (so far) fire ants. Only problem is, the earth could fall out beneath our feet at any time.

Likewise, our politics are famously mild and progressive and our crime rates moderate, with murder stats a fraction of those of comparably sized Eastern and Southern cities. At the same time, this region hosts one of the world's greatest concentrations of artificial destructive force: the Trident submarine base at Bangor and a string of other military bases. And it is the world capital of serial killers: Ted Bundy, the Hillside Strangler, the still-unmasked Green River Killer. It and the inland Northwest are the heartland of neo-Nazi zealots and home-grown terrorists. The contradictions extend even to the most mundane areas of behavior. Though Seattle police scarcely write jaywalking tickets any more, most pedestrians still wait to cross at the light, to the wonder of visitors. But traffic-shocked local drivers no longer show the same forbearance; road-rage violence is becoming a stock local story.

DANGER AND UNCERTAINTY ARE THE SPICES OF LIFE HERE, WHERE CONTINENTS MEET AND WORLDS STILL COLLIDE. SURROUNDED BY SO MUCH DANGEROUS BEAUTY, WE LEARN TO APPRECIATE THE IMPERMANENCE OF THINGS—AND TO ACCEPT THE DANGERS, IF WE WANT TO FULLY ENJOY LIFE ON THESE SHORES.

Inlets and Outcrops

Almost anything can appear
(and probably will) along the
rocky shores of the North
Sound and the straits that
join it to the ocean. Ages and
eras do not vanish here; they
accrue and endure, each on
its sheltered inlet or island,
from ancient tribal traditions
to the Old World ways
preserved by immigrants'
heirs, from the Victorian
charm of Port Townsend
and San Juan Island's Hotel
de Haro to the ghostly
wartime memories of
Bremerton's naval graveyard,
to the countercultural élan
of innumerable earthy
retreats for stress-shocked
urban refugees.

▶ **Snow falls on firs at
Hurricane Ridge near Port
Angeles, looking southwest
toward the glaciers of Mount
Olympus, whose snowmelt
waters the legendary
rainforests of the Hoh and
Queets Rivers. Hurricane
Ridge affords one of the few
automobile accesses to the
Olympic high country and
heart-stopping panoramic
views—when the rain and
snow allow.**

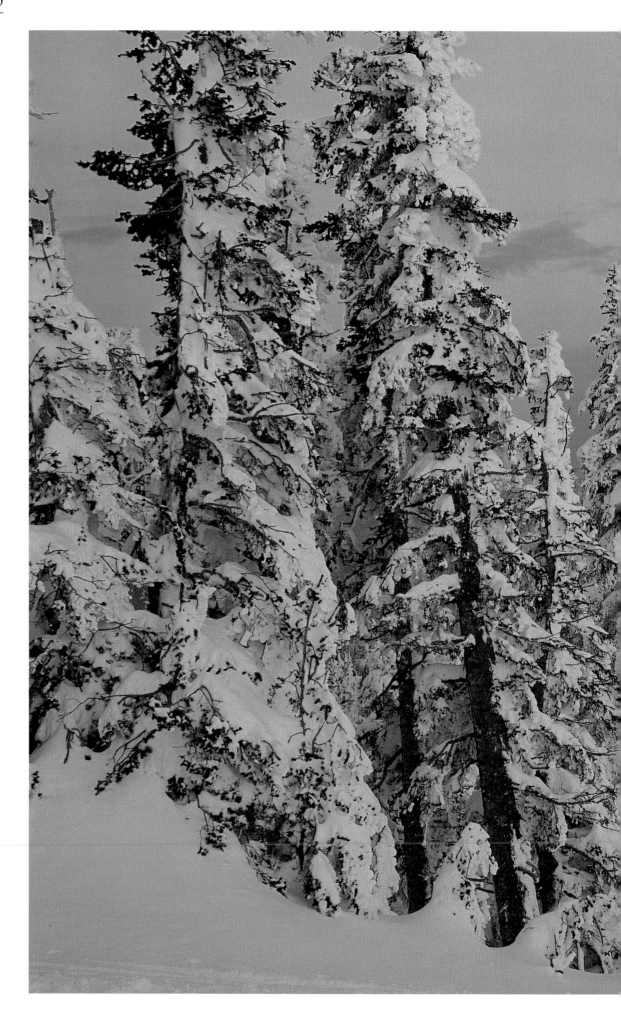

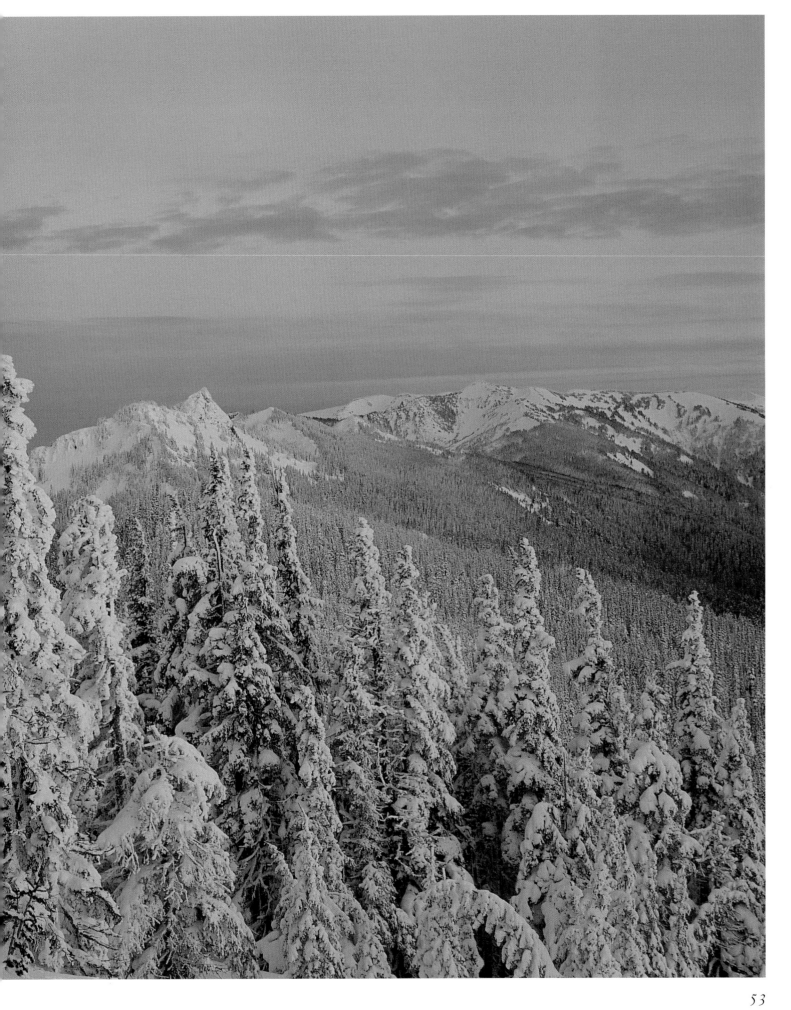

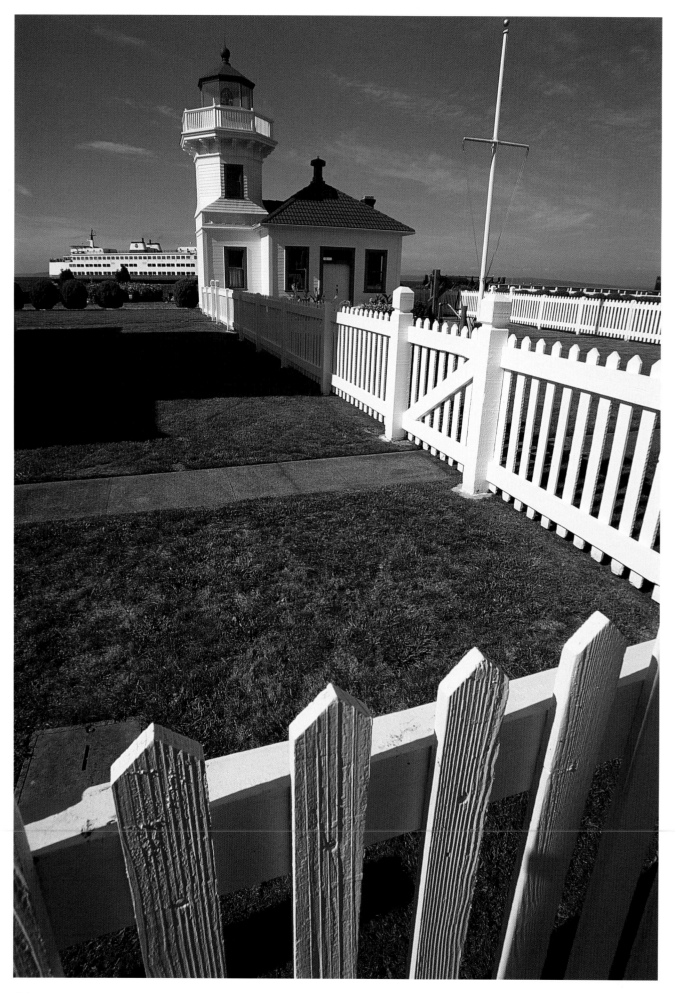

◄ Just past the Mukilteo lighthouse, a Washington state ferry—one in the nation's largest ferry system—sails for Whidbey Island, Puget Sound's largest isle. ► Devotees of teak and canvas form a regatta at Port Townsend's annual Wooden Boat Festival. ▼ The Keystone ferry glides past the eminent Victorians along Port Townsend's landmark Water Street.

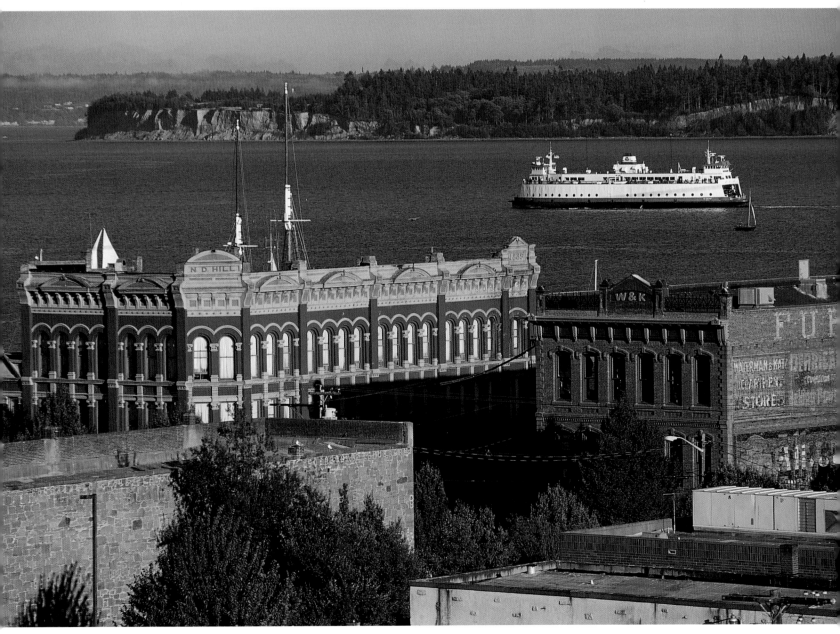

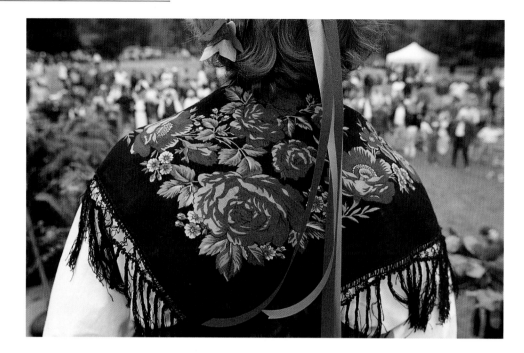

▲ Traditional rose-patterned embroidery and ▶ Swedish country dancing spice up Poulsbo's *Skandia Midsommarfest.* In 1959, community development planners at the University of Washington proposed that this fishing and farming village play up the Scandanavian theme for tourists. But unlike other Northwest towns that have followed similar advice and gone Bavarian or Spanish, Poulsbo has deep roots in the old country. Tourism may have helped it withstand the homogenization that has effaced immigrant traditions in so many other parts of this fast-growing region.

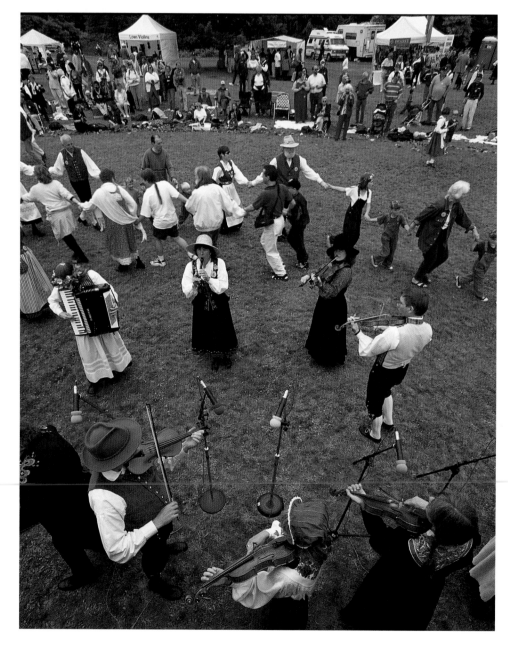

► Three generations of American Natives—including this Lummi elder (top) and two younger generations—stand proud at the annual Chief Seattle Day in Suquamish, a meeting-ground for tribes all around the Sound. The Suquamish homeland, the Port Madison Indian Reservation across Agate Pass from Bainbridge Island, also boasts a museum of Salish culture and Chief Seattle's grave, above which two dugout canoes ride eloquently in midair.

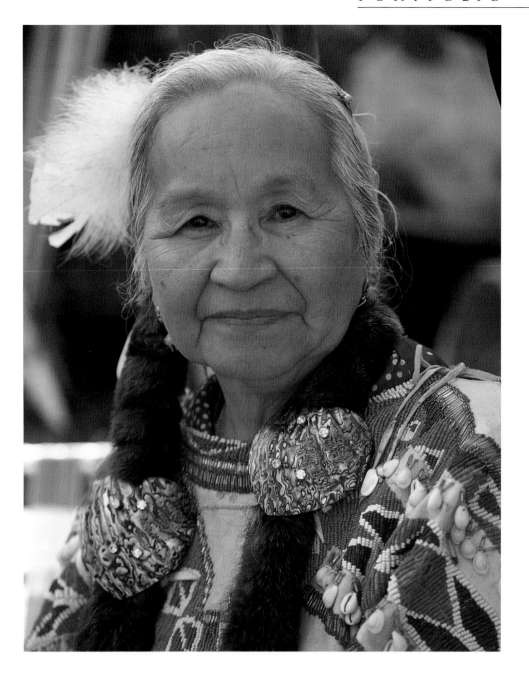

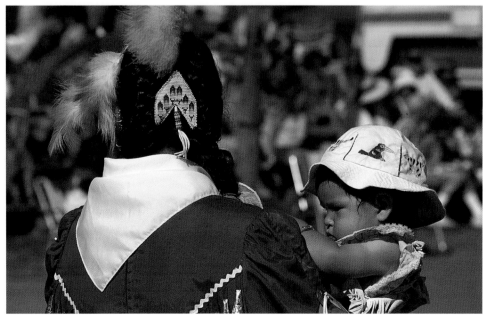

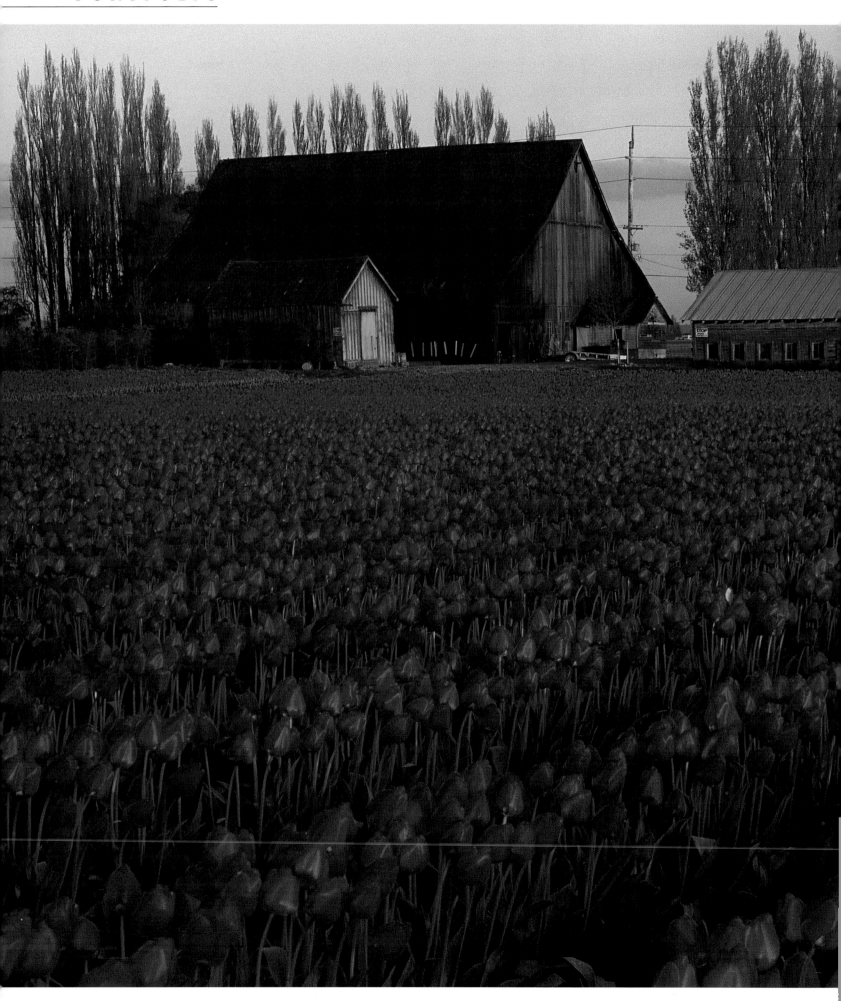

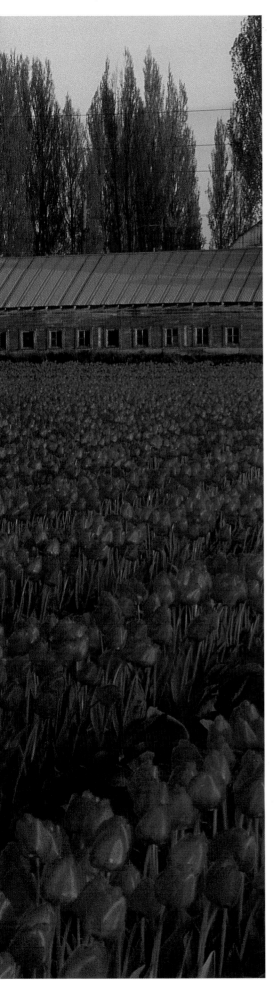

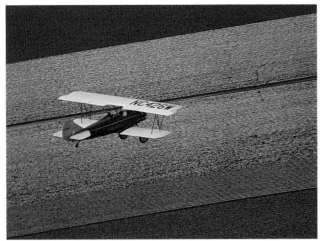

◄ ◄ The rich alluvial flatlands of the Skagit Valley with their stark Cascade Mountain backdrop are ideal for flower growers and ◄ sightseers, who flock here in April to savor the tulip eruption.
▼ Migrating snow geese also flock along the Skagit in early spring. [DARRIN THOMPSON]

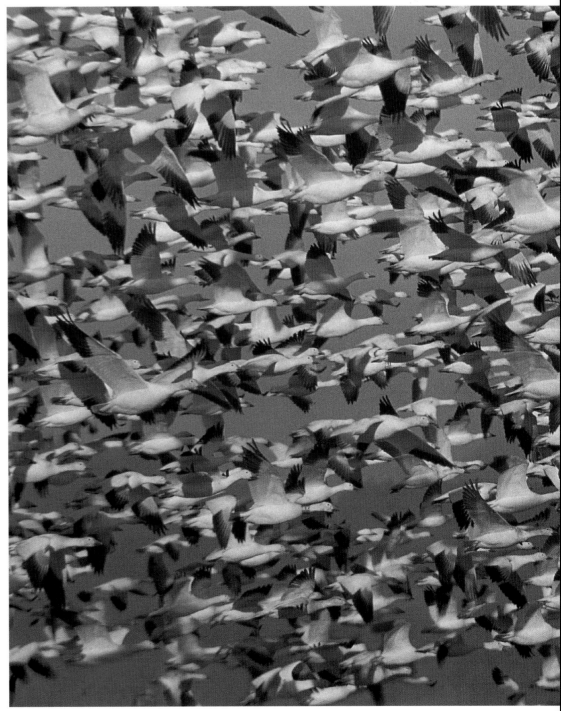

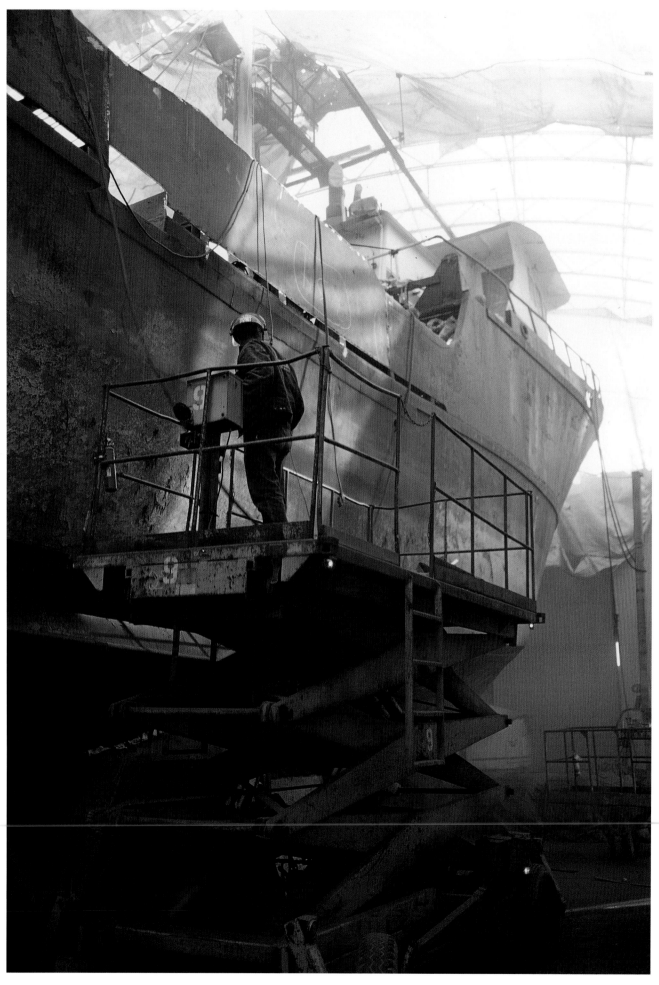

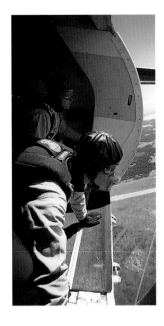

◄ A fishing boat gets sandblasted at Nichols Brothers Boat Builders at Freeland on Whidbey Island. Even as shipyards have declined nationwide, this family-owned yard has thrived by applying innovative design and technology to an old local industry. Nichols Brothers' ferries, excursion boats, and fast catamarans are at work from Antarctica to Vashon Island. ▲ and ► Thirty miles north at the Whidbey Island Naval Air Station, the U.S. Army's Golden Knights skydiving team takes the world's biggest stage over Oak Harbor during the airbase's annual air show.

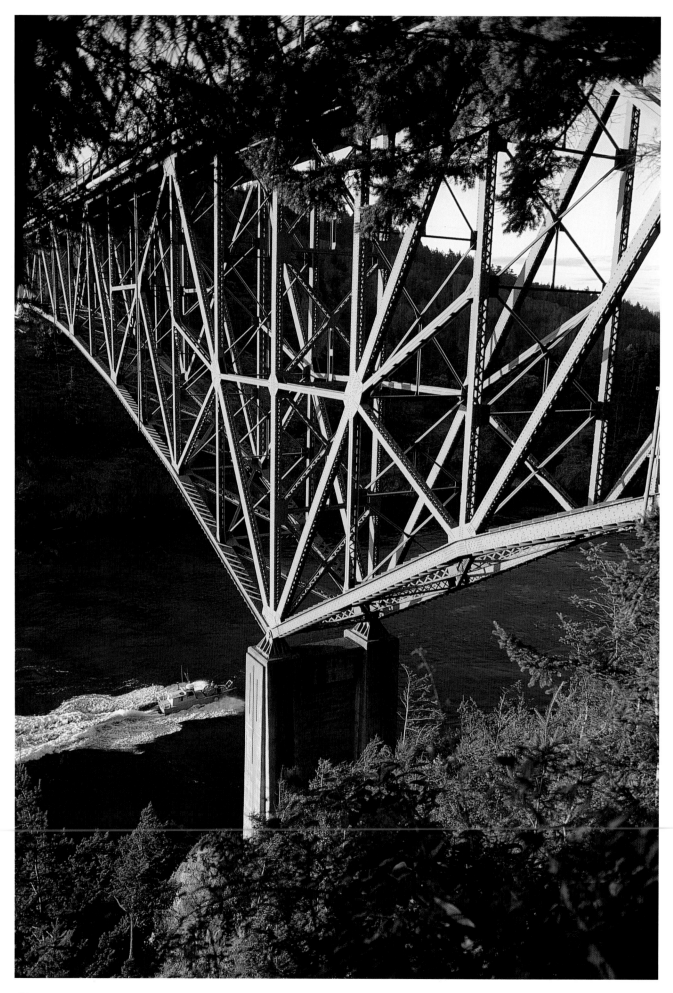

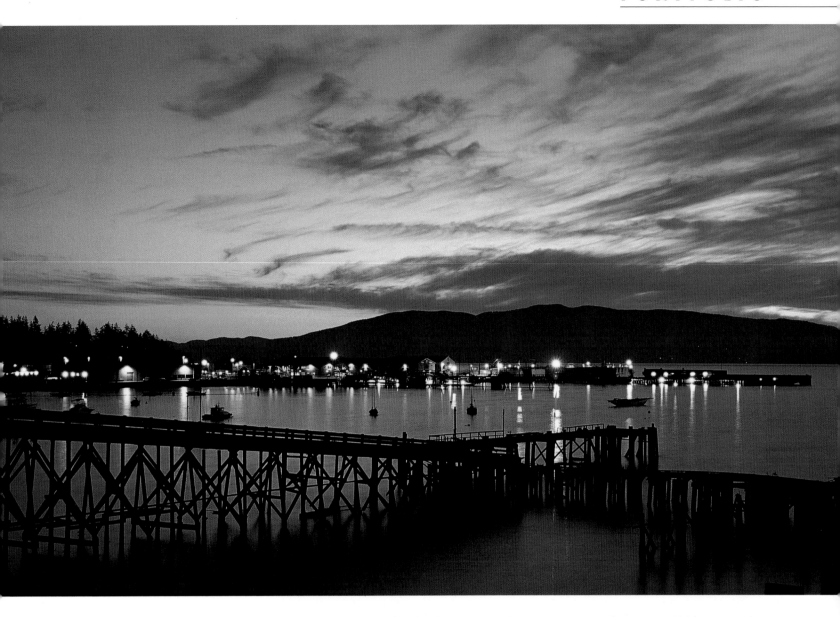

◄ Captain George Vancouver named Deception Pass after discovering it was not, as it first appeared, a shallow bay; the soaring bridge across it joins Whidbey and Fidalgo Islands. ▲ Night falls over Bellingham, the North Sound's main city. ► Midway between Bellingham and the Canadian border, the Morning Star Korean Dance Group from Seattle entertains at the Ferndale Days festival.

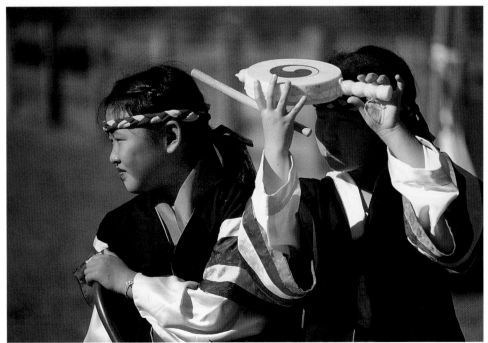

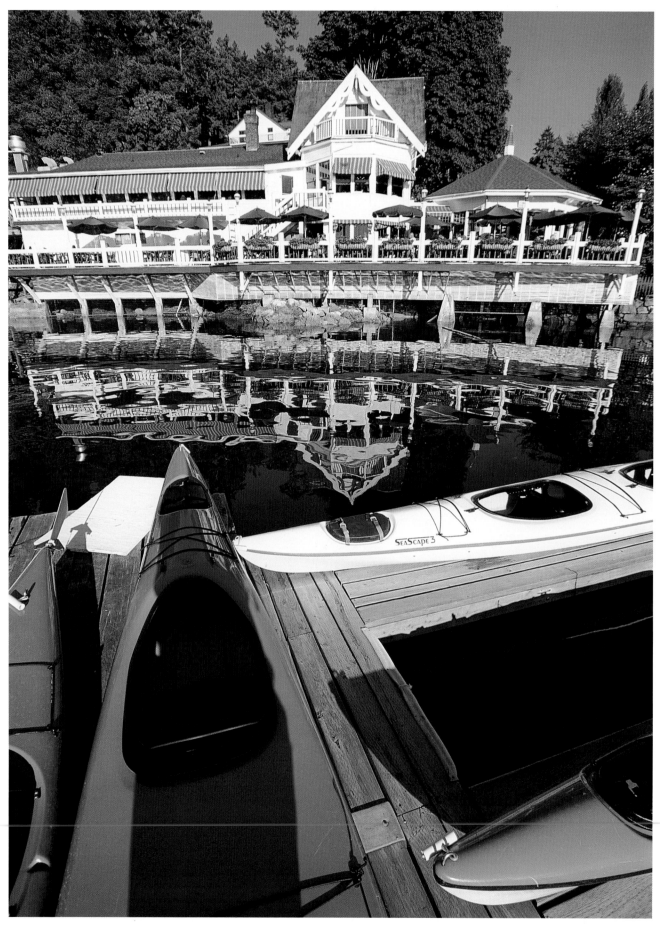

▲ Living *la vida* San Juans: kayaks and deckside dining at Roche Harbor. ▶ *Clockwise from upper left:* New Zealand native Julie Matthews now herds sheep on Lopez Island. Young swingers at a Friday Harbor wedding. Just another island visitor with his stuffed bear waiting for the ferry to depart at Friday Harbor. Watching for the ferry to come in from the porch of the Orcas Hotel.

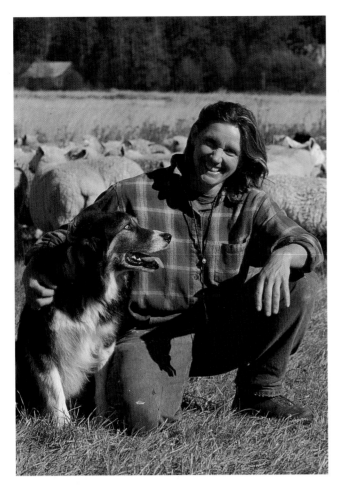

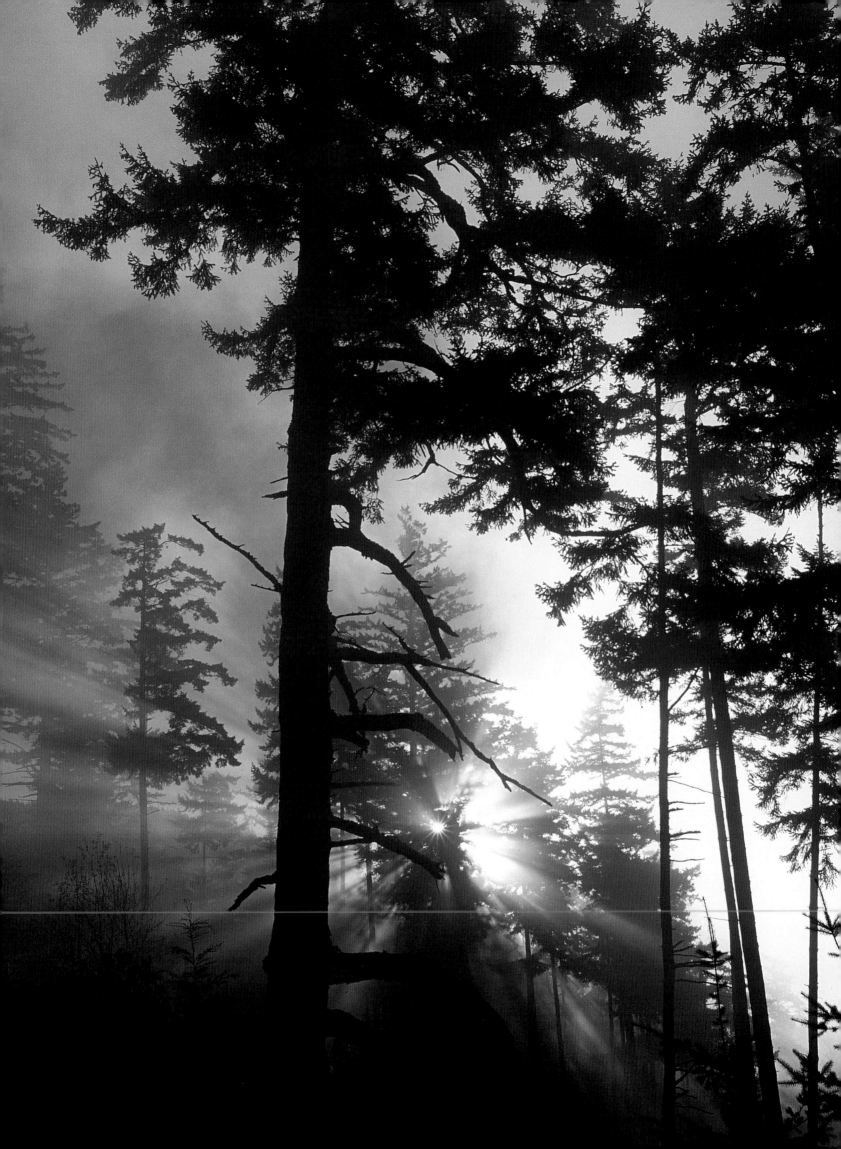

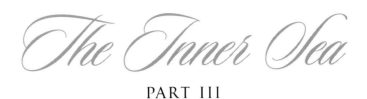

The Inner Sea

PART III

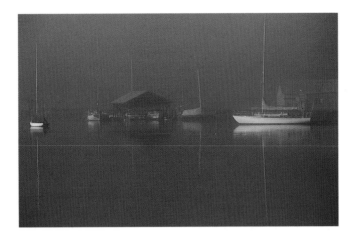

OYSTER LIGHT

▪

Land and water are mutable qualities here, conditions that mix and meld and change places in such dizzying succession that they come to seem arbitrary distinctions. Living surrounded by water, on land shaped by frozen water, where land and water mix and switch, we learn to live with water—or fail to learn, and move someplace else.

In November, walking down the street can seem like swimming in a medium too light to be water and too thick to be air. Every newcomer, seduced (as I confess I was) by the soothing sun of May or August or February's false spring, soon suffers the same damp shock that overtook the Denny party a century and a half ago. November and December arrive and the cycle of day and night changes to night and half-night, a congealed gray that never quite dawns. I once installed a photosensitive porch light that would come on at night and shut off by day, but I had to remove it; it never shut off. "This isn't a city," I heard a colleague exclaim one particularly dank winter, as the first signs of seasonal affective disorder set in. "It's a terrarium!"

Yes, we all know it rains less in Seattle than in most of the East and South—fewer than forty inches most years, fewer than twenty over in Sequim, the heart of the "Banana Belt" that lies under the Olympics' rain shadow. But in rainfall as in cards, length counts more than strength. The skies stay so gray and the clouds

◀ Autumn sun cuts through morning fog, near Rosario Resort on Orcas Island.
▲ Winter light plays hide-and-seek with the fog at Bainbridge Island's Port Madison.

LIVING SURROUNDED BY WATER, ON LAND SHAPED BY FROZEN WATER, WHERE LAND AND WATER MIX AND SWITCH, WE LEARN TO LIVE WITH WATER—OR FAIL TO LEARN, AND MOVE SOMEPLACE ELSE.

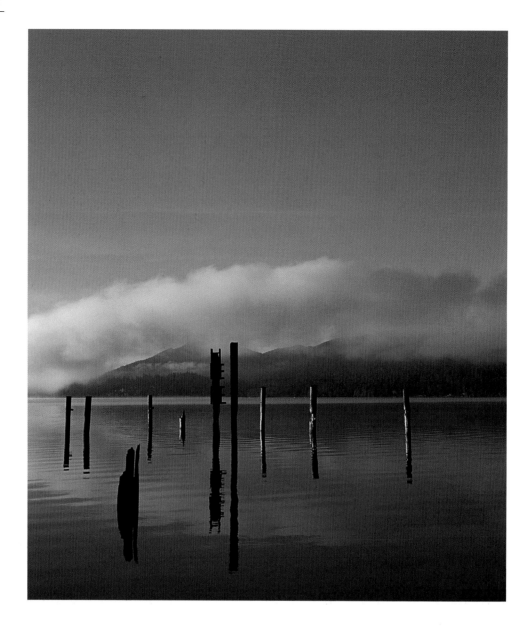

▶ Urban lake, rural serenity:
Cloud and sun dance over
Bellingham's Lake Whatcom.

YOU CELEBRATE THE
"OYSTER LIGHT," THE
DANCE OF CLOUD, FOG,
AND FUGITIVE SUN, THE
INFINITE DEGREES OF
OPACITY AND
TRANSLUCENCY.

last so long because they are always pregnant and never deliver. The rain doesn't *fall* here, as it does in Miami or Chicago or even, when it does arrive, in Tucson; it leaks, dribbles, spits, and sprays. Resistance is futile and umbrellas are useless against this cross between mist and drizzle. You learn to accept, even treasure, the dampness, to wrap it around you like a soggy blanket. You celebrate the "oyster light," the dance of cloud, fog, and fugitive sun, the infinite degrees of opacity and translucency. You sneer at leathery, sun-dried Californians and savor the benefits of pallor, the way skin stays supple, moist, and unlined in our shrouded atmosphere. You start to recite hoary catchphrases: "Oldtimers here don't die, they just rust away," or "You can always tell the locals—they're the ones with moss behind their ears." Instead of "Hot enough for you?" you might ask, "Have you grown your gills yet?" If you don't like the weather around here, don't hold your breath. It'll still be raining tomorrow.

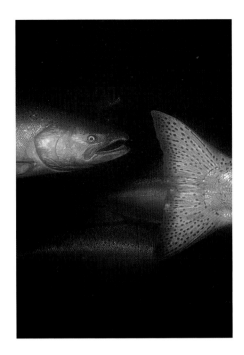

UPWELLINGS

■

Out on the real waters, the reverse is true. Twice each day water becomes land as the tide pulls out over the long, flat, fertile shelves; because tidal variations grow more extreme as you travel north, the Puget Sound Basin has the lowest low and highest high tides in the country, outside Alaska and a few freakish spots in Maine. Step onto the mudflats of Padilla Bay or the wide, cobbled beach at Seattle's West Point or Lincoln Park during a minus 3.5-foot tide and you may think you've stumbled into a *Waterworld* in reverse—that someone's pulled the plug on the whole damned ocean. Step lightly and watchfully along the right tidepool (every step can destroy delicate tidal organisms) and you'll think you've stumbled into an extraterrestrial flower garden, a phantasmagoria that, for sheer strangeness, surpasses even tropic coral reefs. Watch out for lurid orange sea cucumbers, knobbed and spiked like weird medieval weapons or modern sex toys, brawny *Pisaster ochraceous* sea stars nearly two feet across, colored a purple ordinarily found only in bubble gum, and sunflower stars sprouting arms the way Seattle's Eastside suburbs sprout subdivisions. There are billowing thickets of algae and sea lettuce, sinuous and glistening, red and green like decorations for a surrealist Christmas party. Growing farther out but landing in writhing masses on the shore is the most outlandish sea plant of all, the serpentine bladder kelp, a mane of fronds billowing from a balloon-like float atop a stalk that may

▲ Salmon enter Seattle's Ship Canal through the Chittenden Locks, re-enacting the unending upstream cycle of struggle, death, and renewal.

THERE ARE BILLOWING THICKETS OF ALGAE AND SEA LETTUCE, SINUOUS AND GLISTENING, RED AND GREEN LIKE DECORATIONS FOR A SURREALIST CHRISTMAS PARTY.

grow a hundred feet long in a single season—the marine equivalent of the giant upland trees.

If these waters seem to contain an unusual riot of life, that's because they do. "Puget Sound and the rest of the Northeast Pacific are *tremendously* diverse in numbers of organisms and species," says David Secord, a biologist at the University of Washington and expert on such matters. "Biologists from the East Coast are typically amazed when they come out here. Where there might be two, three, or four species of a given genus on the East Coast, there will be a dozen, or two or three dozen, here." This profligacy reflects the biologically favored status of west coasts on all the continents, from Chile to Portugal. Thanks to the earth's spinning, these coasts receive both prevailing westerly winds and ample upwellings of cool, nutrient-laden deep waters, which stabilize temperatures and nourish water and (indirectly) land dwellers alike. On the East Coast the seas warm up markedly in summer, then get so cold they sometimes freeze in winter. Over here, as every brave soul who tries to swim in the Sound knows, the water is consistently cool—chilly enough even in summer to kill within half an hour. That's a drag for swimmers but a boon for the water's residents—except in the ever more frequent El Niño years, when warmer, nutrient-poor waters starve everything from microscopic plankton to mighty salmon.

Secord adds that on all this favored western coast, the richest littoral of all is probably Puget Sound. It is the biggest and deepest of the West's estuaries, with the fastest currents and longest shoreline. Viewed from space, or on any map, the Sound's manifold channels and inlets look like lacework, or the foam left on a glass by a particularly rich ale. And it is this intricate shoreline—more than two thousand miles of it, packed into an area 60 by 100 miles—that makes the difference. In all types of ecosystems, it is at the edges, where habitats meet, that life is most profuse and diverse.

Just as in the old myth, the mountains that enclose the Sound and form a reverse image of it also monopolize its waters. The heaviest rains in the forty-eight contiguous states—over two hundred inches a year—fall on the west slope of the Olympics, growing moss-draped green cathedrals that never dry out. To the east, the heaviest snows in the world fall on Mounts Baker and Rainier, which keep setting one record after another; in the 1998–99 season, Baker received more than 95 feet, surpassing Rainier's 1972 record of 93.5. And these are just the first in a ream of "biggest and best" records held by this land of giants and

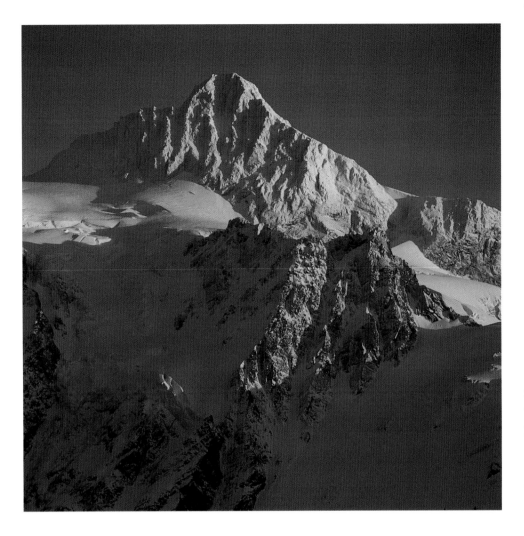

◄ Mount Shuksan in the North Cascades: its name, bestowed by the Skagit Natives, means "precipitous," and the North Cascades contain the steepest peaks and the greatest collection of glaciers in forty-eight states.

sea of monsters. Forget Texas, with its vain boasts and endless empty spaces; it's here, sustained by water, that things *really* grow bigger.

Look first (as you cannot help but look on a clear morning when the mountain emerges from her cloud cover) at Rainier/Tahoma. She is not quite the highest mountain in the Lower 48, but she is easily the most massive and, in net ascent from her base, the tallest, seeming ready to tip right over and crush the city that bears her name. And a few score miles away rise the steepest mountains, with the most glaciers, in all these states—the jagged, dizzying North Cascades.

The abundant rain and snowmelt washing off these peaks nurture an arboreal extravagance below. The old-growth forests—what's left of them—of the Puget and Olympic lowlands are the most productive, in both rate of growth and sheer biomass, of all the world's ecosystems, tropical rainforests included. The Pacific Coast, from Northern California to Southeast Alaska, also contains the world's largest and densest temperate coniferous forest; here, more than in any other temperate zone, conifers overwhelm broadleaf trees. The reason is those wet, mild Mediterranean winters, which give conifers plenty of water to grow on—

while broadleafs, bare in winter, must do their growing during the dry summers.

These conditions nurture the world's biggest and, save for Australian eucalyptus, tallest trees. The Northwest's Douglas fir grows as tall as California's more famous sequoias and redwoods—over three hundred feet—and its Western red cedar nearly as massive, with a trunk more than sixty feet around. The other giants follow in quick succession: Sitka spruce, noble fir, grand fir, Alaska cedar (which grows bigger here than in Alaska), and western hemlock, the good soldier that undergirds the rest of the rain forest, growing dutifully in the other trees' shadows. Though they're at a disadvantage, broadleafs also grow exuberantly here; the big-leaf maple, whose mossy outlines are as much a fixture of the rain-forest as spruce and cedar, is America's largest maple.

In the shadows of such trees, it is only natural that we should imagine monsters—and that many Northwesterners should believe the Sasquatch still roams. Towering, shaggy, loud-bellowing and foul-smelling, he is the most enduring of all this hemisphere's cryptozoological entities. But he isn't the only giant in the woods. The Roosevelt elk, endemic to Western Washington, is the biggest of all the twenty-odd subspecies of red deer that range from Central Asia to Robin Hood's Sherwood Forest. With the wolves that once hunted them exterminated, the elk rule the Olympic Peninsula like kings, brazenly striding into towns like Sequim in search of winter forage, and scrupulously tending their realm; they are the gardeners of the rainforest, nibbling back the surging undergrowth to create natural open parklands.

The Roosevelt elk may be the king of the rainforest, but gardeners minding their peas and cukes suspect that another creature really rules this country: that ravenous, ubiquitous, and elegantly repulsive tube of mucous, the slug. If you suspect your damp plot harbors more slugs than any place on earth, you may be right; those who keep such records account this the most slug-infested terrain anywhere. According to the dean of Northwest naturalists, Arthur Krukeberg, slugs recycle an astonishing 11 percent of the forest biomass each year. And the ten-inch-long banana slug, the one conspicious local species that's actually a Northwest native rather than European immigrant, is the world's second-largest slug.

Immensity is a relative thing, however, and in its sphere even a flea can be a giant. The largest flea ever reported, ten times normal length, was found in Puyallup, Washington.

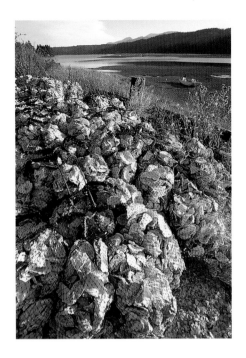

LORDS OF THE SOUND

·

The ancient forests themselves are mostly gone now, logged and logged again, their remnants locked up in a few national parks, wilderness areas, and other scattered preserves (including a shred of old growth in one Seattle park). It's in the deep, dark waters, the realm of the Wasgo and Skaitaw, that the real monsters lurk—so tangible and numerous we've no need to imagine them. Having become Wasgos and penetrated those depths ourselves, we do not postulate other sea monsters; instead, we let Sasquatch fill the psychological needs that the Kraken, Tarasque, and Loch Ness Monster meet elsewhere.

The Sound and straits host an astonishing range of extreme creatures at every biotic level. The sunflower star, a yard wide with two, three, even four dozen writhing legs, is the world's largest and (as starfish go) peppiest sea star. The local weathervane scallop, half a foot wide, is the largest swimming scallop. The ghostly white plumose sea anemone is nearly the largest anemone. The local moon snail, the scourge of clams and oysters, is the largest on earth. When I was a kid mucking around Cape Cod tideflats, we'd delight at finding quahogs and moon snails the size of squash balls. Here on the Sound, the horse clams and moon snails grow big as softballs.

And the geoducks grow big as . . . similes either fail or shock. Contrary to local pride and mistaken reports by such august authorities as *The New York*

▲ Oysters, the Sound's natural treasure and premier crop, thrive in the rich cool waters of Hood Canal.

ON CAPE COD, WE'D DELIGHT AT FINDING QUAHOGS AND MOON SNAILS THE SIZE OF SQUASH BALLS. HERE ON THE SOUND, THE HORSE CLAMS AND MOON SNAILS GROW BIG AS SOFTBALLS.

Times, this outsized, outlandish denizen of Puget Sound's muck is *not* the world's largest clam; tropical giant clams grow much larger. But it is the biggest burrowing bivalve, weighing as much as twenty pounds and stretching its phallic siphon three feet through the sands to reach the plankton-rich waters.

A decade or two ago, the geoduck was a local curiosity: tourists would gasp and photograph it at Seattle's Pike Place Market, while the rest of us cherished it as cheap, delicious chowder meat. But geoducks are now too expensive for chowder, and for Pike Place. In the 1980s, they became prized sashimi in high-flying Japan, till China's newly rich outbid the Japanese, paying fifty dollars and more for a single live clam at trendy Shanghai restaurants. And a new gold rush erupted on the Sound: scuba-diving rustlers with high-powered compressor jets stealing the precious clams from the state-owned seabed. The stakes grew so high one broker of contraband ducks was convicted of taking out a contract on the life of another. Fortunately, state biologists finally figured out how to raise the giant clams (which, contrary to appearance, are very bashful breeders). And the clam rustlers were joined by ranchers, as geoduck beds spread across the tideflats.

The geoduck may be Puget Sound's comic mascot and unlikely cash cow, but it's hardly the lord of the Sound's murky waters. Two magnificent creatures contest that honor. One is obvious royalty: The supreme marine hunter, the mighty orca, chases salmon and (in other seas) seals and other whales with dreadful efficiency and—incongruously for an eight-ton peak predator—plays with puppy-like abandon. And as royalty should, orcas have their faithful retinue, and paparazzi. In the San Juan Islands, boaters and shoreside residents watch the comings and goings of the region's three resident pods, recording each passage for a central log. They even check their sightings against a directory, identifying each of the ninety-odd resident orcas by fin shape and brindle marking. Once scorned as ravening brutes, killer whales are now cherished as brainy, playful renaissance whales, with good family values to boot.

The other, lesser-known Lord of the Sound—or Lord of the Underworld, the master of the bottom depths—is a more solitary sort. The Pacific giant octopus is by far the largest of all octopuses and the biggest-brained of all invertebrates. It may reach twenty feet or more (tentacle to tentacle) in its tragically short life—before it mates, once, when it is three to five years old, and dies. In that time, however, this cousin of the brainless oyster grows a brain that is a marvel of the natural world, comparable in size and, it now appears, complexity

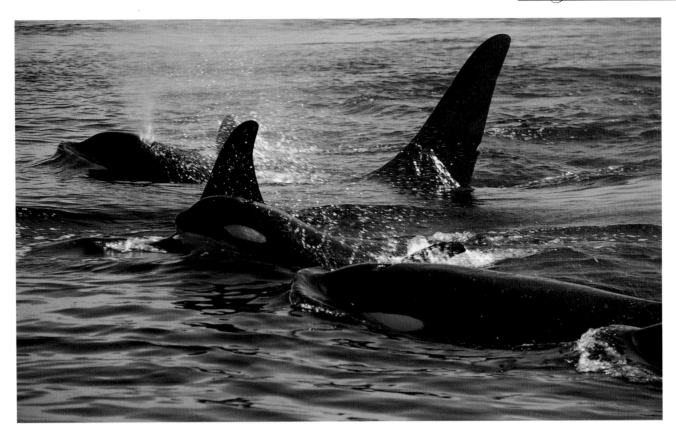

to those of many birds and mammals. Researchers at the Seattle Aquarium and elsewhere have lately discovered that octopuses can learn to recognize individual humans, perform mazes and other learned tasks, and perhaps even transmit such acquired knowledge to other octopuses. The giant octopus undergoes a wide range of moods and emotions, which it displays by changing color from ghostly white to deep purple and dazzling orange. And it exhibits play behavior, something that was once thought to distinguish humans and a few other elite mammals from the dumb brutes; it can while away the captive hours playing catch, using its water jets to bounce floating bottles into the jets of its tank.

Consider the lonely octopus (for octopuses stay alone, until that single mating), brooding in its sea-bottom den. With its oversized brain, does it have some inkling of the mortality that will so soon overtake it? How might the medieval scholars, who saw animals as embodiments of human traits, describe the giant octopus? Perhaps as an emblem of the hermit, the mystic poet or painter seeking Zen tranquility in the deep woods—or the paranoid wacko waiting out Armageddon in his wilderness bunker. Both are Northwest archetypes— Gary Snyder and Morris Graves on the one hand and, on the other, Theodore Kaczynski, Randy Weaver, and Robert Mathews, the neo-Nazi terrorist leader immolated in a Whidbey Island shootout. Or consider our giant octopus and

▲ The mighty orca, the ocean's peak predator and the Sound's most hallowed resident, thrived after captures ceased in the late 1970s, but is now threatened by shrinking salmon stocks.

75

giant sea star as examples of a different sort of Northwest archetype—their umpteen arms reaching hungrily in all directions, enveloping their prey in a smothering embrace. Imagine them as counterparts of Microsoft, the alpha predator of the upland ecosystem and the commercial giant par excellence not just of this region, or country, or time, but of all human history. Or perhaps the killer whale, the alpha predator supreme, is the better model: Though those in the Sound catch only fish, orcas can bring down great whales many times their size, just as Microsoft bested giant IBM.

But before there was software, before airplanes and ships, even before sawmills, the wealth along these waters was fish—salmon, to be specific. And even today, it is salmon, more than any other creature or phenomenon, that defines our relationship with these lands and waters.

That relationship is both enriched and complicated by the essential fact of salmon life: it is anadramous. Instead of living out their lives in fresh or salt water as most fish do, salmon require both: They lay their eggs in the sheltering gravel of cold-running streams. Then, as they mature, they pass down to the sea and fatten on its larder, roaming thousands of miles before they return—almost unerringly—to the same birth streams to spawn and, like the octopus, die.

This cycle conferred a unique evolutionary advantage on salmon and the trout, smelt, and char that also practice anadromy: their eggs and fry could incubate outside the free-for-all of the open sea while the grown fish feed at the sea's feast. But now it makes them uniquely vulnerable to all the things that humans do to the seas and rivers and the lands above. One dam blocking the passage upstream, one clearcut that exposes the stream to the baking sun, one heedless road project that smothers a spawning redd with silt, or a thousand doses of backyard weed-killer dribbling into the stream, and it's goodbye to one more salmon run.

Goodbye to much more as well; the salmon runs are this region's great unifying force, the thread that stitches together land and sea in ways that are both exalted and as mundane as roadkill. The salmon's gawdy spawned-out carcasses, littering the streambanks by the thousands, represent an important transfer of nutrients from sea to land. Creatures ranging from bears to aquatic larvae and microorganisms—including salmon fry themselves—feed on them, and in turn nourish the forests themselves. Only recently have land managers realized the importance of this cycle and begun scattering spawned-out hatchery fish along the streams.

THE SALMON RUNS ARE THE GREAT UNIFYING FORCE OF THIS REGION, THE THREAD THAT STITCHES TOGETHER LAND AND SEA IN WAYS THAT ARE BOTH EXALTED AND AS MUNDANE AS ROADKILL. THE SALMON'S GAWDY SPAWNED-OUT CARCASSES, LITTERING THE STREAMBANKS BY THE THOUSANDS, REPRESENT AN IMPORTANT TRANSFER OF NUTRIENTS FROM SEA TO LAND.

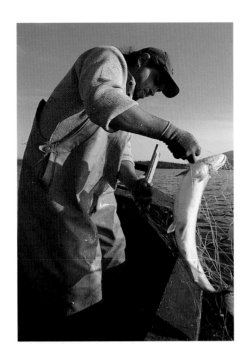

POTLATCH

·

The returning salmon are much more than compost in the life of the Sound; they define the region. "The Pacific Northwest is simply this: wherever the salmon can get to," writes Tim Egan in *The Good Rain*. For the first Northwesterners, salmon were the staff of life, the core of their culture and the key to their identity, as essential as buffalo were to the Plains Indians (and easier to catch). Countless Northwest myths recount how Coyote or another benefactor saved the first people from hunger by teaching them to catch salmon—just as the Greeks honored Prometheus for bringing humankind fire.

The people of Whulge boiled salmon, dried it, smoked it, mashed it with berries—feasting now and lardering it away for the months when the fish did not run. And salmon was only the main course in their natural smorgasbord. They also caught shorebirds, ducks, herring, trout, halibut, rockfish, cod, seals, sea lions, sea otters, even (on the ocean coast) great whales. Easier pickings yet could be had with a little digging and gathering down on the tideflats. Even today, the shellfish harvest can be luxurious—as long as you avoid red tides, sewage outfalls, and protective beach owners. On an untended beach, a few minutes sifting can fill a bucket with native littleneck clams—delicious steamers that commercial gatherers don't even bother with, preferring Manila clams transplanted here from Asia. "When the tide's out, the table's set," goes the old watchword on

▲ A Lummi tribal fisherman pulls a salmon from his gillnet on Portage Channel, west of Bellingham.

"WHEN THE TIDE'S OUT, THE TABLE'S SET," GOES THE OLD WATCHWORD ON THE SOUND.

the Sound. Or, in the updated version I recently heard from a young Makah: "When the tide's out, the refrigerator door's open." The appliances change, but the bounty remains the same.

That bounty first drew people to settle along the Sound, and then provided the stuff of their material and mythological cultures. It consisted of much more than sea critters; the early Puget Sounders made even more varied and ingenious use of the forest's plants, though largely not as food (with no nutritionists to make them eat vegetables, they luxuriated in a meat and seafood-rich diet). Every plant had its use, from pillows of moss to mallets of rock-hard yew. But one plant was supreme, and supremely useful: the "tree of life," red cedar. Perhaps no other people anywhere have put one plant to so many uses as the Northwest Natives did cedar. They scorched, hollowed, steamed, and stretched its trunks to form fine-lined seagoing canoes sixty feet long. They carved masks, toys, utensils, and virtually everything else that could be carved from its soft, forgiving wood. They peeled off great strips of its inner bark, then split and twined these to make thread fine enough for sewing and ropes strong enough to tow whales. They wove waterproof baskets from its coils, and formed waterproof boxes from its wood. They shredded the bark to make cloth for blankets, cloaks, and even diapers, and chewed on it to relieve headaches and stomach aches. Because cedar splits straight and easily, they rent it into beams and planks that seem surely to have been milled. And while the Plains Indians stretched hides to form teepees, and the Californians daubed together huts of stick and mud, the Northwesterners built vast post-and-beam cedar longhouses shared by many families, with private quarters walled off by cedar mats and set around a great recessed fire and meeting place.

This natural wealth nurtured a rare culture of affluence, not just for a tiny elite but for the general populace. It afforded leisure for art and storytelling, resulting in the extraordinary creative flowering of the Northwest coastal cultures. And it reached its apotheosis in the *potlatch* (from the Chinook jargon for "giving"), a custom that was widespread across North America but raised to its greatest elaboration and significance on the Northwest Coast. Lavish potlatches were held to celebrate all manner of occasions, from births and deaths to marriages and house-raisings, to cement communal and intertribal bonds, and to elevate a family's status. Guests would paddle for days to reach potlatches that might run for weeks, with feasting, drumming, chanting, dancing,

THEY CARVED MASKS, TOYS, UTENSILS, AND VIRTUALLY EVERYTHING ELSE THAT COULD BE CARVED FROM ITS SOFT, FORGIVING WOOD. THEY PEELED OFF GREAT STRIPS OF ITS INNER BARK, THEN SPLIT AND TWINED THESE TO MAKE THREAD FINE ENOUGH FOR SEWING AND ROPES STRONG ENOUGH TO TOW WHALES.

invocations—and gambling and courting on the side. The culmination was the famous giving ceremony, when hosts would lavish everything from canoes to cash to calico cloth on guests. The wealthier ones might disperse considerable fortunes in the process, while the less wealthy impoverished themselves to keep up.

Around 120 years ago the Indian agent Myron Eells noted that the potlatch "seems mainly confined to those Indians who live near the salt water, as it would be difficult for those who have to travel on horseback to carry the amount of articles which they have need of on such occasions." This had changed by the time I attended a potlatch given by the Makah Tribal Council in 1998; a loaded truck from the nearest Wal-Mart pulled up to the community gym's side door. Smiling teenagers circulated through the crowd distributing gifts: dolls and Hot Wheels for the children, bath towels and kitchenware for adults, smoked salmon and home-baked pies for everyone. The drumming, dancing, singing, and speech-making went on hypnotically through the night.

For all its modern trappings, this potlatch still celebrated the bounty of the waters—albeit a bounty that many outside the tribe, and some within it, saw more as tragedy. It was held to commemorate the Makah's first whale hunt in seventy years—a hunt the tribe insisted on undertaking in the face of impassioned protests, to affirm their treaty rights to the waters that had nurtured their peoples for millennia. And the potlatch "giving"—at once redistributing wealth and using wealth to bind individuals to the group—seemed an especially apt tribute to the immense collective bounty of a whale kill.

Watching as the booty was handed out, I could not help but think of the potlatch's modern counterpart, the primary mechanism by which this region's immense new high-tech wealth is being distributed: the employee stock option. Like the potlatch, with its subtexts of patronage and obligation, stock-option "golden handcuffs" are gifts that bind, as employees wait for their lucrative options to vest. Like the potlatch, employee stock options are not unique to this region; companies around the country grant them. But nowhere else have they become so central an institution, or effected so massive a distribution of wealth, as here—where one company alone, Microsoft, has in two decades spawned thousands of millionaires and at least six billionaires. In August 1999, its employees were waiting to exercise a mind-boggling fifty-two billion dollars in options; today, Senator Everett Dirksen might say, "A billion here, a billion there, and pretty soon you're talking about Microsoft money."

The Cascade Corridor

Stretching north and south from Seattle above the Sound's eastern shore, the Cascade Corridor has seen more booms and busts than any place should have a right to. Timber towns sprouted like mushrooms in the foothills to harvest the green gold that grew on the mountain-blocked rains. The giant trees are gone or protected now, but the loggers still celebrate the days when "they tried to cut it all." After losing the pulpmill stench they once cherished, Seattle's old rivals Everett and Tacoma now find new life while Bellevue, a new rival, booms across Lake Washington.

▶ **Lila Lake gleams, reflecting Mount Hibox and Box Ridge in the Alpine Lakes, a hiker's paradise in the Central Cascades. ▶▲ The moon rises over Mount Baker, the northernmost Cascade volcano and the snowiest place on earth. ▶▶ Mountain waters rush toward the Sound at Twin Falls, near North Bend and Snoqualmie Pass.**

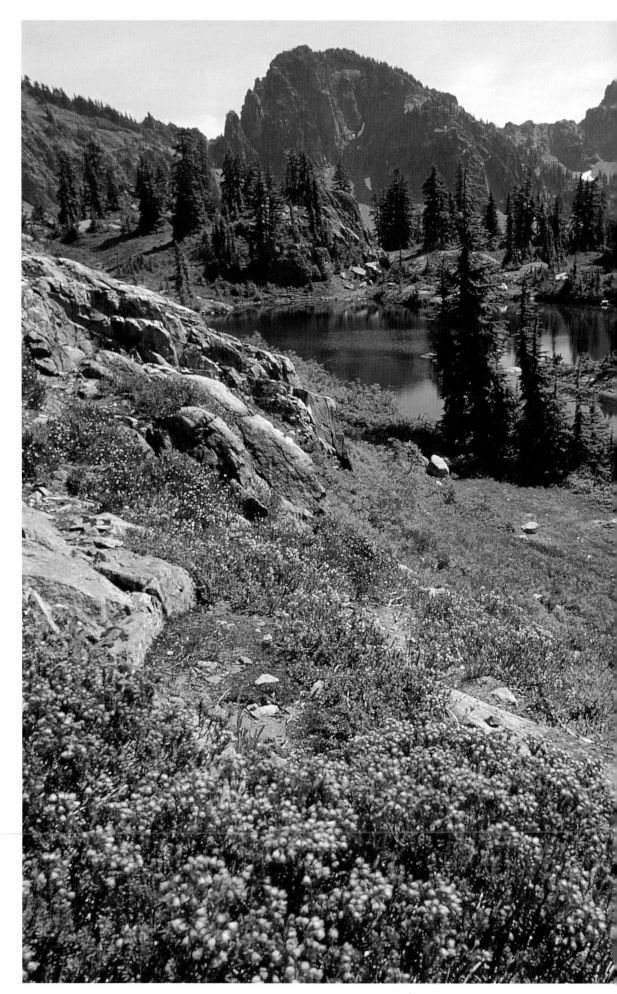

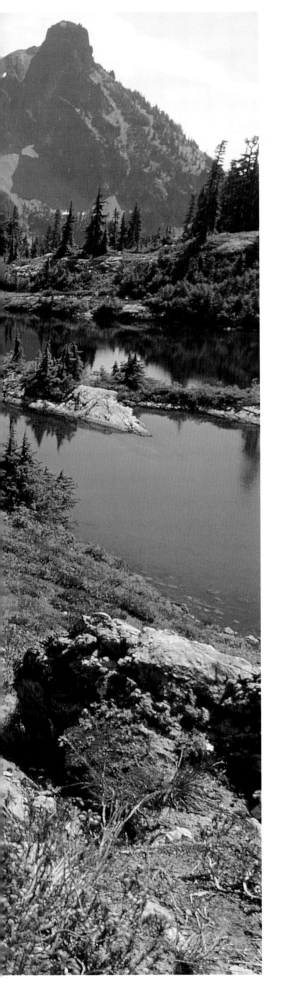

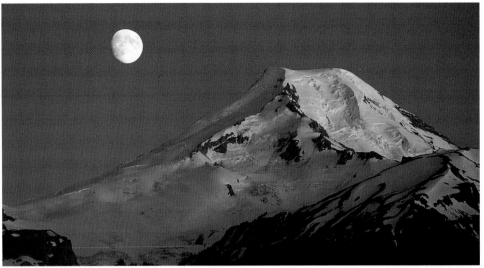

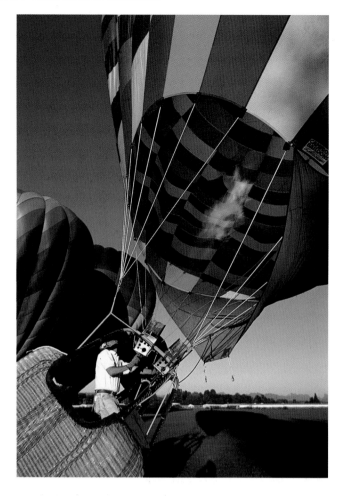

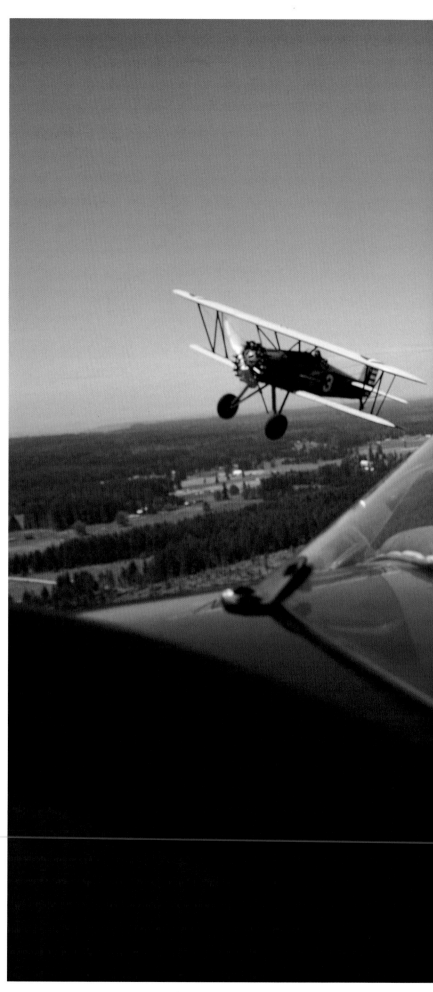

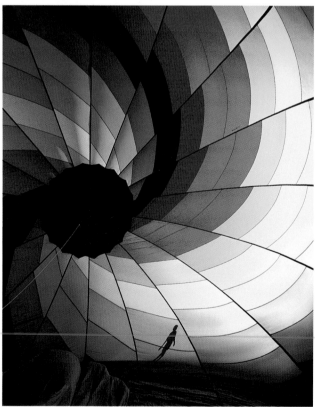

▲▲ and ▲ Hot air fills balloons at Snohomish's Harvey Airfield, a mecca for aficionados of all types of airborne sports. ▶ Geologist Phil Taylor works with earth but plays at Harvey Airfield, in a biplane he assembled himself.

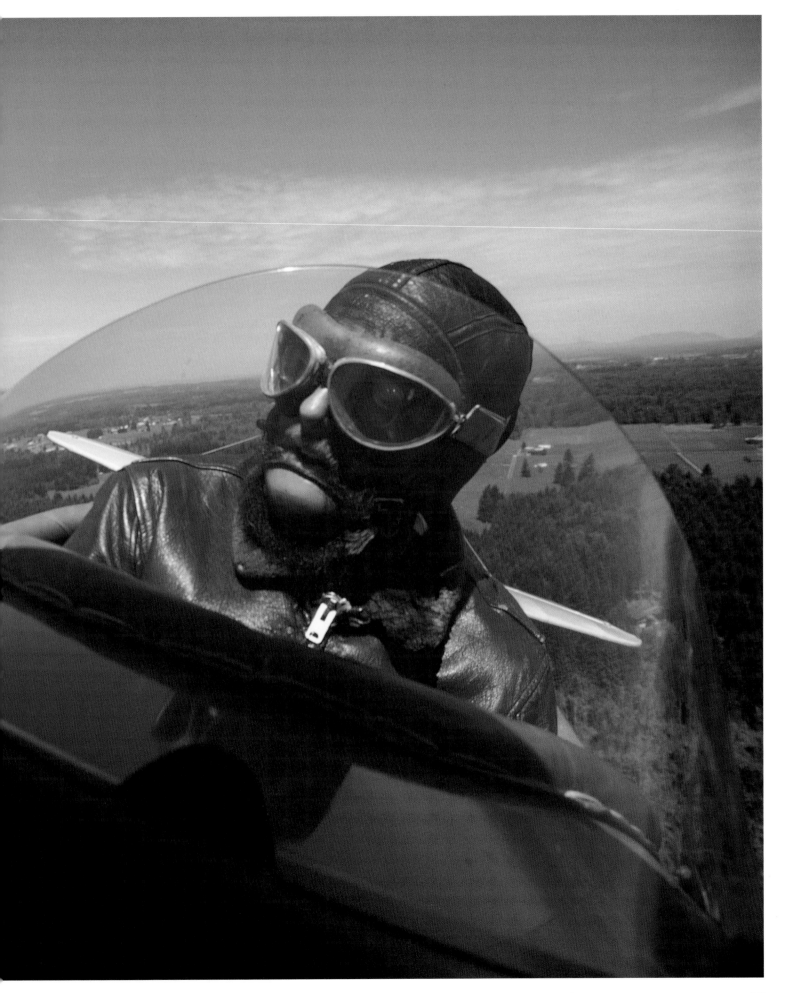

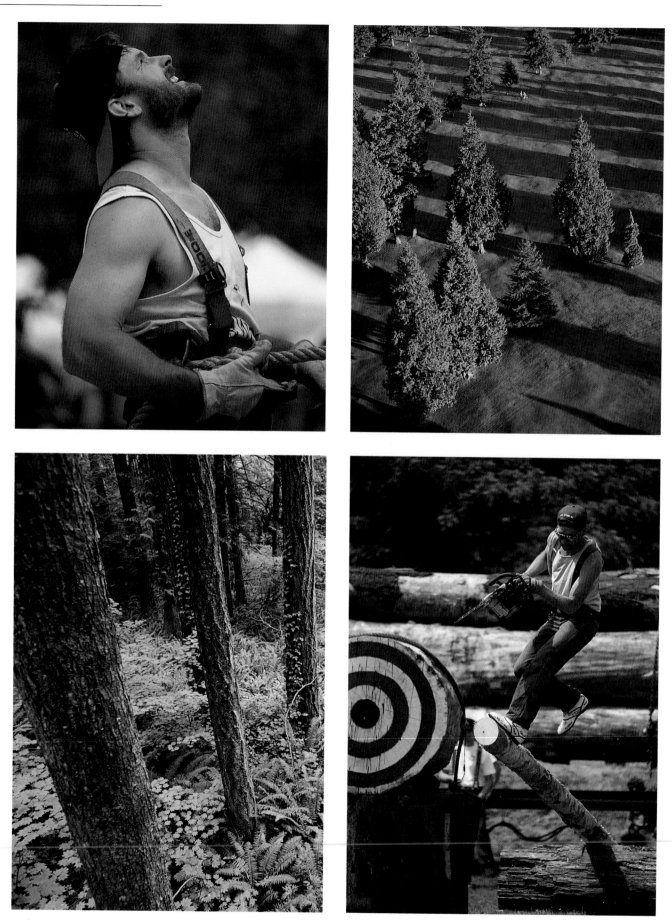

▲ *Clockwise from upper left*: A logger watches a trunk-climbing competition at the Sultan Summer Shindig. Late afternoon sun bathes Kenwanda Golf Course near Snohomish, one of many spreading where ancient trees once stood. Another Sultan contestant races to cut through a mighty log and loses his balance. And protected old growth stands amid lush ferns near Snoqualmie Falls. ▶ Slack flow in early September at Snoqualmie Falls; sightseers cherish the falls, and Native peoples revere them.

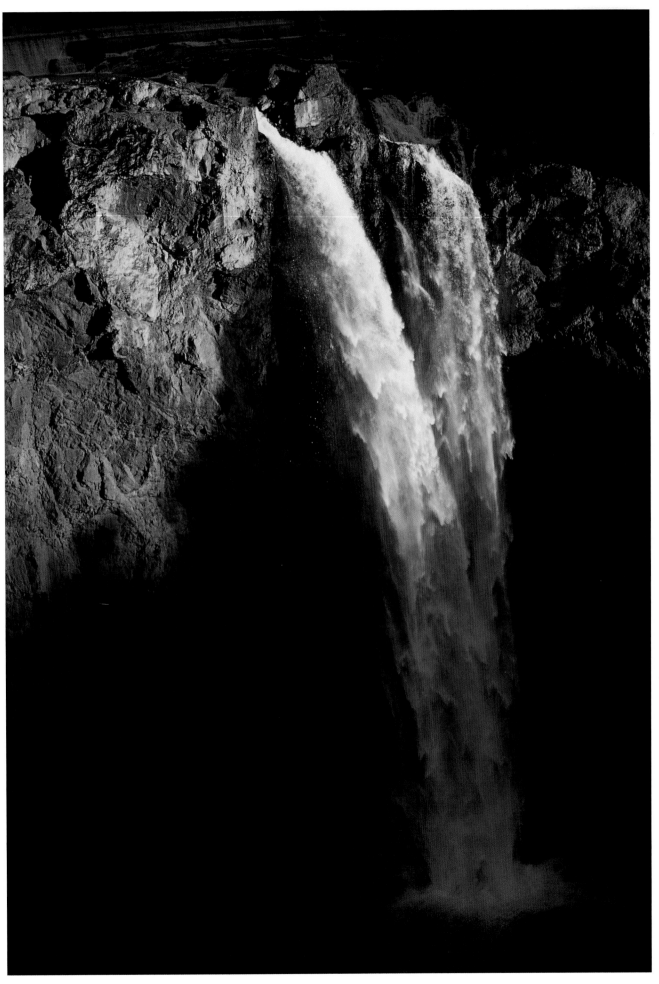

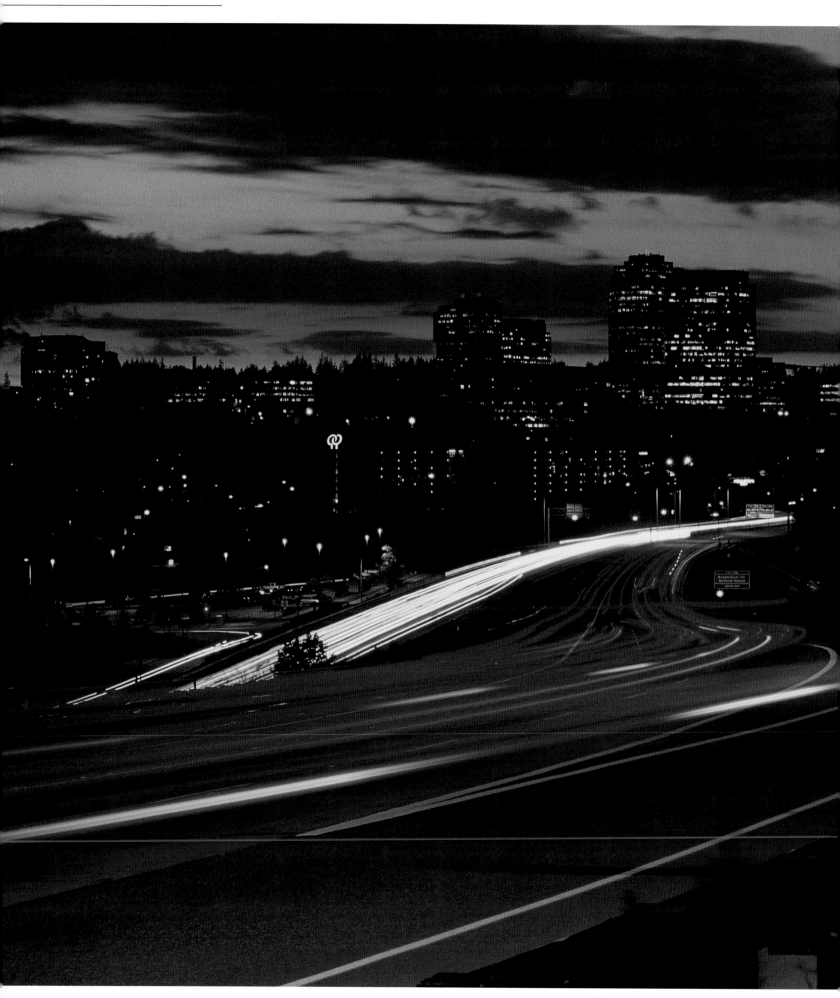

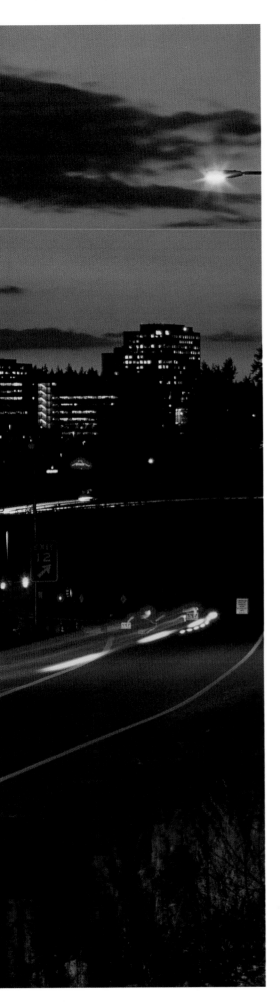

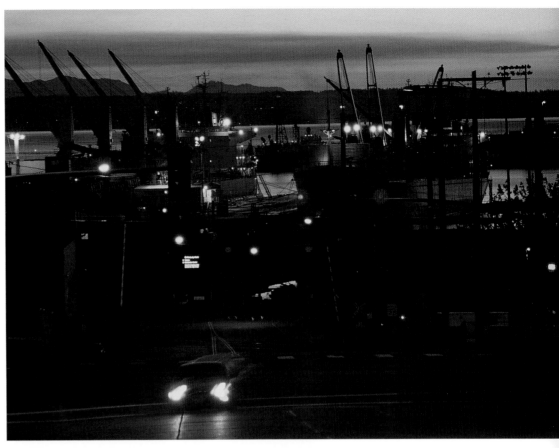

◄ ◄ Bellevue's young skyline twinkles across Interstate 405. From blueberry farms in the 1940s to a bedroom community in the 1970s, Seattle's biggest Eastside suburb has boomed into a powerhouse of commerce and technology. ▲ Everett, the quintessential pulp and lumber "milltown," found new life as a U.S. Navy homeport after the mills closed. ◄ The Boeing 747 plant in South Everett, the world's biggest building by volume, builds the world's biggest jet carriers.

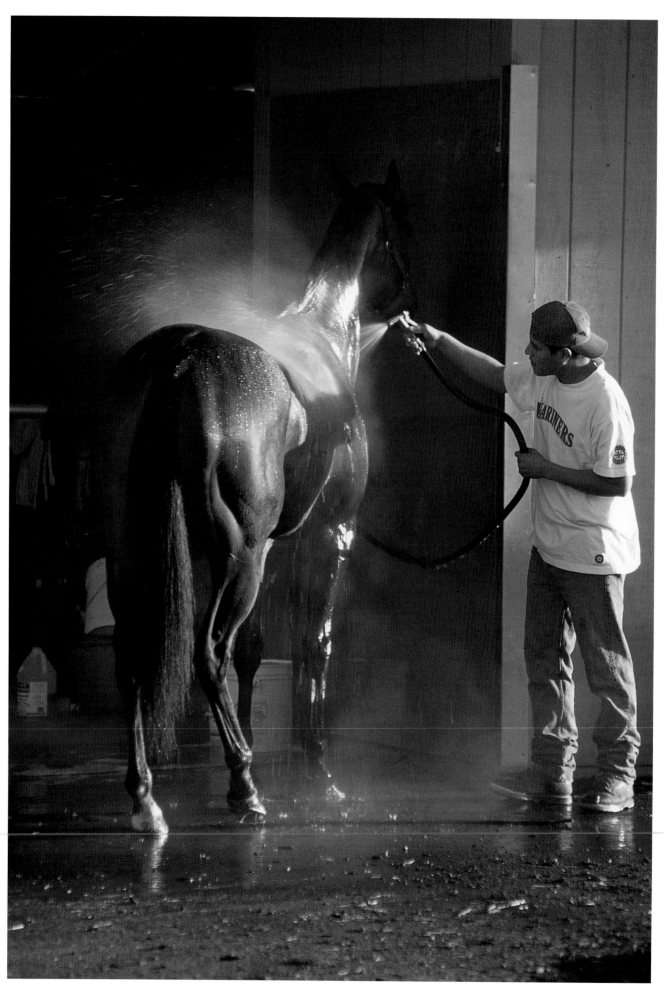

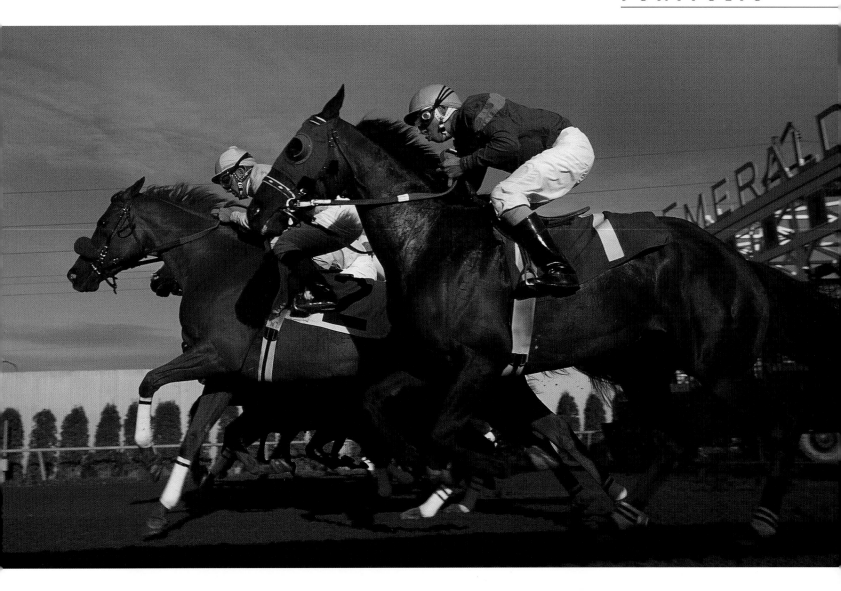

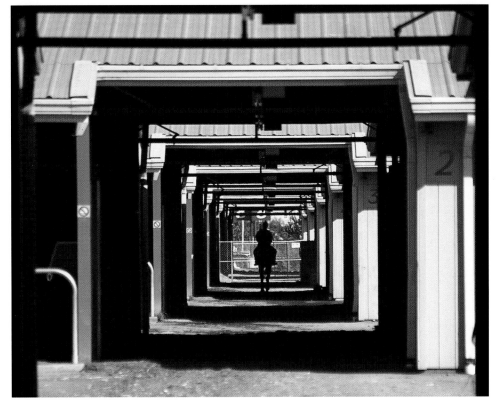

◄ *Clockwise from facing page:* The morning bath; the break out of the gate; and the return to the stable—daily rites during the race season at Emerald Downs in Auburn, the Northwest's largest horse-racing track. The Downs opened in 1996, four years after Longacres, its fifty-seven-year-old predecessor to the north, closed in the face of Boeing's expansion. Three years later it finished with a whopping $120-million "handle," proving that a gambling spirit predating the Europeans' arrival still thrives on the Sound.

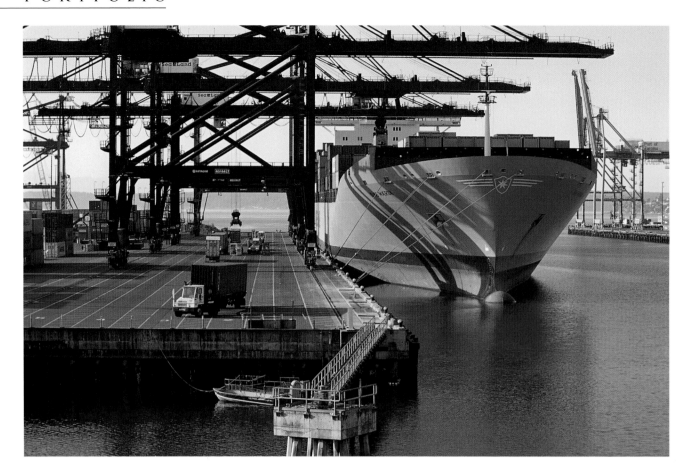

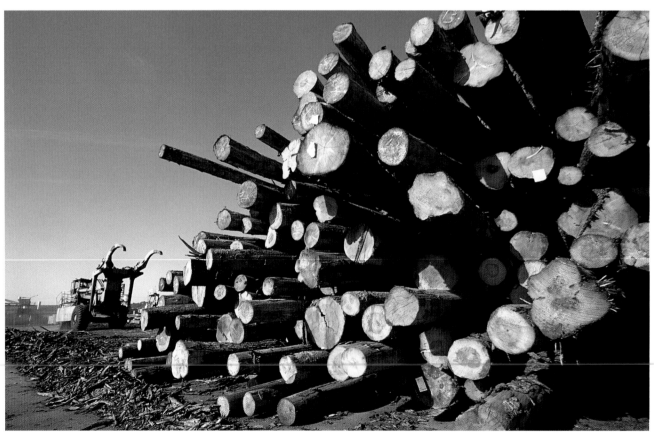

▲▲ Just outside the region's booming high-tech economy, remnants of the old resource-based (some say "colonial") economy endure. At the fast-growing Port of Tacoma, which has lured away some of Seattle's biggest clients, cranes stand ready to unload electronics and other manufactured goods from Asia. ▲ Logs wait to ship out from the Louisiana-Pacific yard at the Tacoma docks. ▶ Dale Chihuly's glass undersea creatures lend a biomorphic charm to Tacoma's Union Station, now renovated as a courthouse.

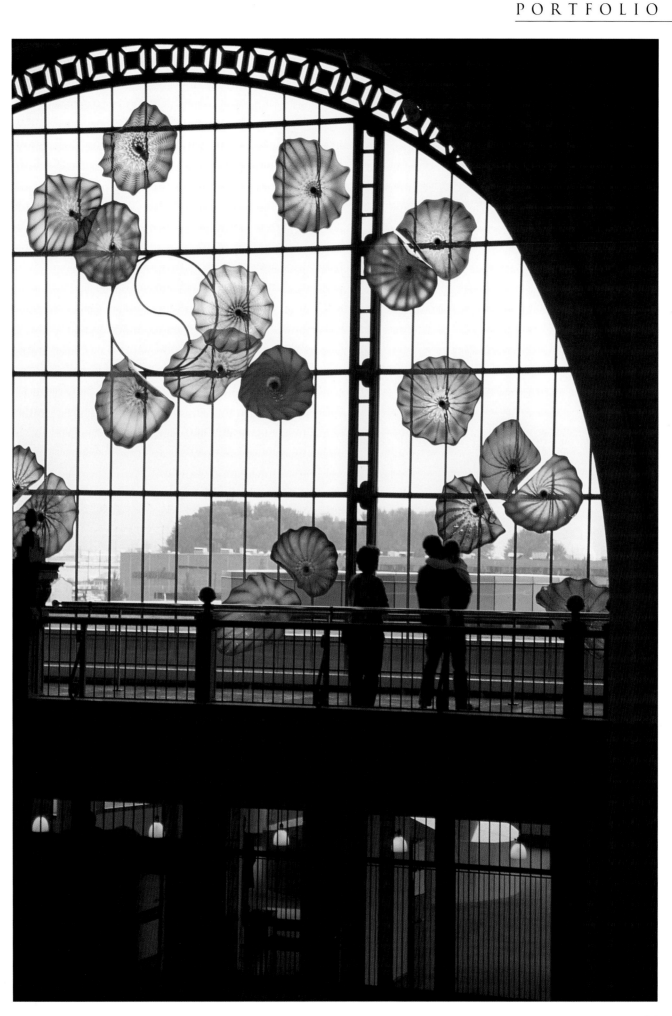

▲ Young fairgoers swing free at the Western Washington Fair, held each fall at Puyallup's fairgrounds and known to locals simply as "the Puyallup." ▶ Grandma gives grandson a helping hand at Olympia's *Bon Odori* festival. ▶▶ The rotunda of the soaring Capitol dome in Olympia, faced in Alaska Tokeen marble, has just the dizzying, overpowering effect intended in such public edifices. But Washingtonians nevertheless tend to show their government little reverence.

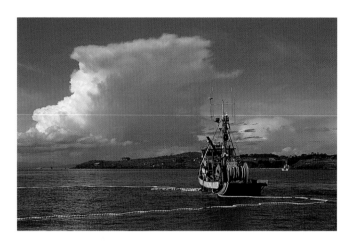

WUNDERKINDER

·

The pace at which Microsoft options have appreciated seems downright stodgy to a newer generation of *wunderkinder* at even more meteoric start-up companies. The twenty-six-year-old software engineer in jeans and T-shirt has replaced the twenty-six-year-old grunge rocker (in jeans and T-shirt) as the trendy Seattle archetype. Like each of the other new economies that have erupted here ("boom" is inadequate to describe them), the cyber-economy is changing life along the Sound in ways we who are living through it can hardly guess at. But as in each of those previous transformations, the new wealth remains tied to, and ultimately derives from, the Sound itself.

That connection is obvious in the early waves of mariners and fishermen who flocked here to mine the wealth. First, at the end of the eighteenth century, came the fur hunters—Russian overseers in great skin boats paddled by Aleut vassals, followed by flinty Yankee traders and Hudson's Bay managers—speedily depleting the precious sea otters. Over the next century, non-Native fishermen—Greek and Croatian immigrants at first, followed by better-capitalized operators from the East Coast—arrived to take a share of the seemingly limitless salmon. At first it was a cottage operation, packing barrels of salted fish for the California market. The construction of the first cannery, at Mukilteo in 1878, sowed the seeds of a vast new industry, and of the salmon's destruction. Canning and freezing

◄ New giants soar above the Sound: the Matson Navigational Company docks in Seattle. ▲ A purse seiner scoops up the sea's silvery gold south of San Juan Island.

THE TWENTY-SIX-YEAR-OLD SOFTWARE ENGINEER IN JEANS AND T-SHIRT HAS REPLACED THE TWENTY-SIX-YEAR-OLD GRUNGE ROCKER (IN JEANS AND T-SHIRT) AS THE TRENDY SEATTLE ARCHETYPE.

made it possible to ship fish from the Sound (and oysters from the South Sound's beds) around the world.

Between furs and fish-packing, another extractive industry grew, exploiting the region's biggest physical resource of all—its trees. The timbermen's dependence on the Sound may not be so obvious as the fishermen's and oystermen's, but it was no less real. By 1849, San Francisco, growing like topsy to serve the inland gold rush, was ravenous for lumber. Trees weren't the issue; they grew for a thousand miles of coastline to the north. *Water* made all the difference—safe, accessible, navigable water. Trees were only timber if they could be dragged or floated to California-bound ships. But most of the Northwest coastline was walled by cliffs, rocks, and crashing breakers. Humboldt Bay and the Columbia River pierced this wall but had deadly sandbars. Puget Sound was far and away the biggest, deepest, safest entry—a sheltered, timbered waterline waiting to be sheared. And Seattle had the most favored spot on the Sound: a deep harbor, nearer the ocean outlet than its rival Tacoma and much nearer the railroads than its earlier rival Port Townsend. Plus it nestled in water on *both* sides; with the opening of the Hiram Chittenden Locks in 1917, Lake Washington on Seattle's eastern edge and Lake Union at its center became extensions of the Sound.

The water link also made possible the headiest boom of all on the Sound: the 1897 Klondike Gold Rush, which transformed Seattle and, to a lesser extent, Tacoma from backwater milltowns to bustling ports and real cities. The gold was two thousand miles away in the Yukon. But the miners and prospectors shipped out from, and were supplied from, Puget Sound. And they sent their spoils back here. This, arriving soon after the transcontinental railroads finally reached Tacoma and Seattle, began the region's transformation from a resource colony to an international trading hub.

Then a world war broke out, and another. Both fueled ferocious shipbuilding booms on the Sound; in 1943, the Bremerton Naval Shipyard and sixteen scattered private yards held contracts for two hundred ships. A new industrial economy had arisen, far surpassing trees and fish and other traditional water-dependent resources. But still the Sound was essential; the new industries literally grew from the water up.

That's true even of the biggest local employer of all, the Boeing Company, though its water link is not often appreciated. It all began on the Fourth of July,

WATER MADE ALL THE DIFFERENCE—SAFE, ACCESSIBLE, NAVIGABLE WATER. . . . AND SEATTLE HAD THE MOST FAVORED SPOT ON THE SOUND: A DEEP HARBOR, NEARER THE OCEAN THAN TACOMA AND NEARER THE RAILROADS THAN PORT TOWNSEND.

1914, when two former engineering students, Bill Boeing and Dick Westerveld, took a ride on a barnstorming seaplane at Lake Union. They liked it so much they went up again and again—and then decided they could build something better than the rickety biplane they had luckily escaped crashing in. Boeing had an edge in the nascent aircraft business. After coming to Seattle to make his fortune in timber, he'd turned to building yachts. Now he used his shipyard to build wings and pontoons for seaplanes; with land runways scarce in those early days, being by water was a key advantage. So were cheap lumber, then the main component of airplanes, and skilled woodworkers, likewise plentiful in timber country. "Built Where the Spruce Grows" was the new company's slogan. Later, cheap hydroelectric power and the aluminum milled with that power would also serve Boeing as it grew to become the world's biggest aerospace firm and America's last surviving commercial jet maker. Today it has a workforce surpassing the populations of some eighteen of the world's nations. Its 747 plant near Everett is the world's biggest building by volume—a humbling sight, and one more on the region's roster of giants.

But Boeing has been surpassed in glamour and in dollar value by a whole new class of local giants. In 1999 Microsoft, which dominates the world software industry, was worth eleven times as much as Boeing. That same year the net worth of Microsoft chairman Bill Gates, the biggest Wasgo of them all (and the world's richest person) surpassed one hundred billion dollars. And Microsoft is only the grandest example of the local knack for creating giant enterprises from humble products (in Microsoft's case, the personal-computer operating system) that the rest of the world had overlooked. Out of the humble cup of coffee, Starbucks has erected a global empire of thousands of coffee houses. In just four years Amazon.com has leveraged mail-order bookselling to become the "Wal-Mart of the Internet," a firm aspiring to transform, perhaps dominate, retailing in the next century.

Why does all this happen on Puget Sound? For three primary reasons: brains, beauty, and the elusive but potent force called "critical mass." The new *wunder*-firms could in theory locate anywhere; they need no resources save their employees' skills and their venture capitalists' checkbooks. And yet they choose to locate in the "Silicon Forest" east of Seattle or Seattle's own fast-growing silicon shoreline. Gates and Paul Allen, Seattle natives both, founded Microsoft not in Seattle but in dusty Albuquerque, where the high-tech action was in the late

1970s—and then moved it to Redmond, Washington. In the 1980s, crack-peddling street gangsters were the most celebrated, or notorious, California emigrants. Today, transplanted software firms are followed by trendy restauranteurs exploiting our new zest for conspicuous consumption.

In the late '70s and '80s, a tsunami of "livability" hype washed over the Sound. First *Harper's* declared Seattle "the most livable city in America," then other media and pundits followed suit, and went on to dub Olympia, Bremerton, and other Puget Sound spots the most livable small city, most livable affordable city, and so on and on.

In the 1990s, the refrain changed, but the tune remained the same. First *Fortune*, then *Forbes* declared Seattle the best place in the country "to do business"—despite the fact that, as *Fortune* noted, Seattle's own captains of industry disparaged its "anti-business attitude." What trumps this attitude (and trumps a tax structure that's not especially business-friendly) is the critical mass of innovative enterprises here, the tangible beauty of Puget Sound country, and the less-tangible "quality of life" that goes with it—what's sometimes called "the mountain factor." (When Mount Rainier shows, the factor's at full strength.) *Fortune* cited both these as bases for the region's prosperity. *Forbes* specifically cited the region's quotients of open space and waterfront. These are the qualities that distinguish Seattle and the Sound from the computer revolution's original California heartland. "Don't underestimate the importance of Puget Sound's quality of life in drawing the talent and money that make the region such an emerging area for venture capital activity and technological innovation," Brian Cassidy, the cofounder of the Eastside Internet firm Webforia, told the *Puget Sound Business Journal.* "Although Silicon Valley has reigned as the preeminent venture capital and high-tech hub, it has become very polluted and over-crowded." And so it's on to Puget Sound, which is so much more picturesque and not so crowded or polluted—yet.

"The classic line is, 'You have to be where smart people want to live,' "says Susannah Malarkey, the executive director of the Seattle-based Technology Alliance. "That means cultural life *and* the outdoors." Malarkey recalls the lesson that the local biotechnology powerhouse Immunex learned when it ran various ads trying to recruit scientists to the far Northwest. The layout that worked best showed the company's planned waterfront headquarters against a splendid Puget Sound vista.

WHAT TRUMPS THIS "ANTI-BUSINESS ATTITUDE" IS THE CRITICAL MASS OF INNOVATIVE ENTERPRISES HERE, THE TANGIBLE BEAUTY OF PUGET SOUND COUNTRY, AND THE LESS-TANGIBLE "QUALITY OF LIFE" THAT GOES WITH IT—WHAT'S SOMETIMES CALLED "THE MOUNTAIN FACTOR." (WHEN MOUNT RAINIER SHOWS, THE FACTOR'S AT FULL STRENGTH.)

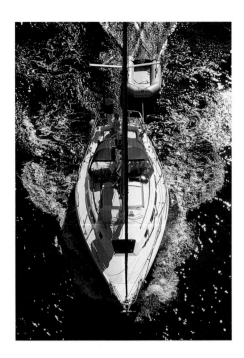

TECHREPRENEURS

·

The new *techrepreneurs* may fancy themselves as having one foot in the future, but they stand upon a local tradition of innovation going back centuries: to the do-it-yourself airplane maker Bill Boeing, to the dreamers and boomers who imagined mighty cities—"the City of Destiny" (Tacoma), "New York Someday" (Seattle), even a Port Townsend metropolis—rising from the woods and tideflats, to the first residents, conceiving their ingenious cedar technology, their elaborate art and mythology, during those long, rained-in, salmon-fattened nights. The Sound's shores have always attracted visionaries, dreamers, and eccentrics—starting with Doc Maynard, Seattle's foremost founding father, an alcoholic, bigamist, polymath physician with a heart of gold and an eye to the future.

The geek tycoons who are the latest incarnation of this type aren't merely drawn to the region; like the salmon people and lumber people before them, they gravitate to the water's edge. At first the Silicon Forest sprouted in the suburbs east of Seattle, with Microsoft at its center. But another generation of Microsofts is leaving or eschewing the inland sprawl for Seattle's historic waterfront. In 1999 *The Seattle Times* reported that Pioneer Square alone was home to seventy software firms. Visio, Pathogenesis, and Real Networks overlook Seattle's waterfront. Immunex and Go2Net are moving their headquarters to piers right on the water. Paul Allen is building a massive complex for his various enterprises on

▲ A sailboat passes under the Agate Pass bridge near Suquamish between Bainbridge Island and the Kitsap Peninsula.

THE SOUND'S SHORES HAVE ALWAYS ATTRACTED VISIONARIES, DREAMERS, AND ECCENTRICS— STARTING WITH DOC MAYNARD, SEATTLE'S FOREMOST FOUNDING FATHER, AN ALCOHOLIC, BIGAMIST, POLYMATH PHYSICIAN WITH A HEART OF GOLD AND AN EYE TO THE FUTURE.

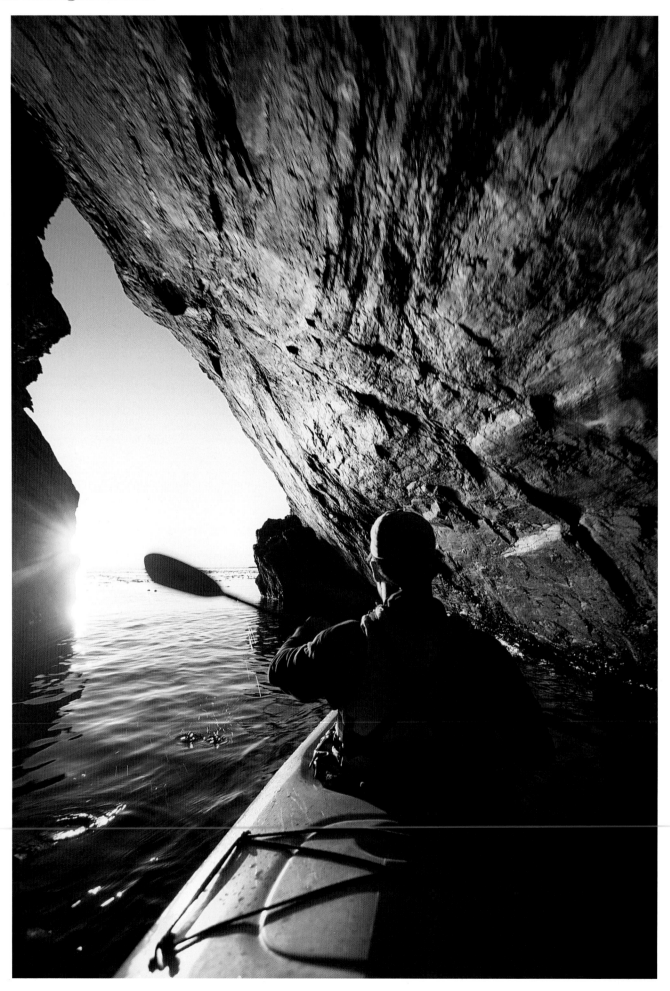

the site of—how the order changeth!—an old sawmill at the foot of Lake Washington. The scullers in the Washington Rowing Club must tote their shells past Adobe Systems' waterfront compound on Lake Union. And Dale Chihuly, the supreme artist/showman of the new Northwest, who has done for art glass what Starbucks has done for espresso, works (with his army of assistants) in a sprawling wide-windowed studio beside Lake Union. Many of his forms, from delicate *objets* to enormous chandeliers, derive from squiggly undersea creatures.

In the past, local moneybags hid their fortunes behind the trees, in secretive, gated communities like The Highlands north of Seattle. Discretion and restraint were watchwords; ostentation was vulgar and "Californian." No more. Now wealth is as brazen as, well, a potlatch. The Sound and, especially, Lake Washington shorelines have become showcases for the new tycoons. Allen and Gates have built sprawling lakeshore mansions. Gates' sixty-million-dollar estate is the main show for the sightseeing tourboats that cruise this gold coast several times each day, the waterborne equivalent of Beverly Hills star tours. The guides delight in pointing out another waterfront estate that figured in "the most expensive divorce settlement in the state's history," that of the billionaire cellular-phone pioneer Craig McCaw—naturally, a floatplane pilot.

We of more plebeian means likewise cherish our water links. We pile into stadiums by the waterfront to root for football's Seahawks and baseball's Mariners. We keep some sort of boat around—even if it's just a scratched-up kayak leaning against the side of the house—so we can fancy ourselves always ready to take to the Sound, even if we never have time to. In 1957, *Popular Boating* reported that Seattle had the highest rate of boat ownership in the country; urban legend or not, that finding has been local gospel ever since. State officials estimate there are 450,000 registrable boats in this state, half of them in the three central Puget Sound counties, and more than 3,000 yachts worth one hundred thousands dollars or more. That doesn't include the most characteristic of all Puget Sound watercraft, the kayak. Indeed, the modern sport of sea kayaking, and the crafting of fine-lined kayaks in fiberglass, developed largely as a cult pursuit along Puget Sound. The finest kayaks and paddles are still made here. And in 1993 the State of Washington inaugurated a network of outdoor trails that would sound crazy anywhere else: the Cascadia Marine Trail System, stretching from the Sound's southern tip to the San Juans' western edge, with campsites reachable only by water.

WE OF MORE PLEBEIAN MEANS LIKEWISE CHERISH OUR WATER LINKS. INDEED, THE MODERN SPORT OF SEA KAYAKING, AND THE CRAFTING OF FINE-LINED KAYAKS IN FIBERGLASS, DEVELOPED LARGELY AS A CULT PURSUIT ALONG PUGET SOUND.

◄ A paddler negotiates a sea cave on Lopez Island. Puget Sound offers kayakers thousands of miles of shore and channel, including a designated state Marine Trail System with paddle-in campsites.

For those lacking even a kayak, the water is still just a two-dollar ticket away, on one of the green and white boats in the nation's largest ferry fleet. For those who ride them, the state ferries are an endless source of delight, exasperation, and pride. Delight because you never know when your eyes will be seized by a splendid play of light and cloud on the dark waters, perhaps even a passing whale. Exasperation at lines of cars that can stretch for hours or, in the San Juan Islands, all day in the tourist season. And pride because the ferries set us apart from the rest of the land-bound, quotidian world—and, for those who live across the Sound, afford protection against teeming, booming Pugetopolis.

So we cling to our inconvenient ferries and shout down the state officials who, every decade or so for half a century, have proposed *bridging* the Sound so traffic can really move and the Olympic Peninsula can really develop. (In 1948 they also sketched out a network of submerged traffic tubes under the Sound.) And each time the islanders who would supposedly benefit have screamed holy murder at the growth and intrusion such efficient access would bring. So do Seattleites, each time officials posit a second Evergreen Point floating bridge across Lake Washington to relieve ghastly commuter congestion. The water that others might see as a barrier, we cherish as a buffer.

Perhaps it's just as well so many bridge-building plans have been stymied, when our bridges have such a nasty habit of collapsing. That first Tacoma Narrows Bridge, the unforgettable "Galloping Gertie," shook, shimmied, and snapped apart four months after opening in 1940. The first floating bridge across Lake Washington, likewise proclaimed an engineering marvel when it was built in 1940, sank fifty years later. The first Hood Canal Bridge had already beaten it to Davy Jones' locker by eleven years. The year before that, in 1978, a wayward freighter wrecked the West Seattle Bridge. All these spans have been replaced, but the lesson endures: We cannot master these waters. We must live with them.

GENTRIFICATION

.

Still we overrun the shores, in ever-greater numbers. Between 1990 and 2010, the Puget Sound region's population was projected to grow by a million; by the late '90s it was ahead of projection, adding seventy thousand people each year. Suburbia now shades into an exurbia of what had been remote rural retreats. Ninety miles from Seattle, on the west side of Fidalgo Island, overlooking grand views of the Sound and San Juans, sprout subdivisions that seem lifted whole from Seattle's Eastside suburbs. Officials in bucolic Skagit County, which includes Fidalgo, were shocked to discover that its biggest employer was . . . Boeing, down in Snohomish and King Counties. More and more Puget Sounders submit to L.A.-scale commutes that lately seemed unthinkable, to recapture some of the magic of living on the old Sound.

This outward push turns some long-running environmental battles upside-down. In the 1920s the South Sound's shellfish growers were the first in the region to sound the alarm over pollution; they saw their oyster beds dying and blamed the unchecked effluent from nearby pulp mills. Now the mills have either cleaned up or shut down and the shellfish have returned, but the same fight still rages, with a difference: Retirees and other waterfront residents are fighting to stop the growers from planting mussel rafts and oyster racks in the inlets they share. The residents warn of pollution—even though shellfish

▲ The bones of trees that escaped the sawmill's blade wash up on Lopez Island's Spencer Spit. Public beaches like this one are an all-too-rare attraction on many parts of the Sound, where private owners hold most of the waterfront. Conservationist and hiking guru Harvey Manning has even taken the matter onto his own feet, walking hundreds of miles of privately owned beach to prove his right to be there.

MORE AND MORE PUGET SOUNDERS SUBMIT TO L.A.-SCALE COMMUTES THAT LATELY SEEMED UNTHINKABLE, TO RECAPTURE SOME OF THE MAGIC OF LIVING ON THE OLD SOUND.

are filter feeders, which remove more detritus from the water than they put out.

Strolling the South Sound's Tauton Inlet on one midnight minus tide, I happened to witness a spontaneous debate between one anxious waterfront homeowner, Don Acheson, and shellfish grower Jim Gibbons, whose crews were busily tending the oysters with miner's lights strapped to their heads. Gibbons pressed Acheson to admit that residents' objections to shellfish growing were "all aesthetic" at heart. "We have a right to some aesthetics," replied Acheson. "Human beings still need some areas to call their own, without [those areas] being commercialized."

But aesthetics itself fuels the latest wave of commercialization, as those who can afford it grab their slices of natural beauty. From Vashon Island, off Seattle's south shore, to the San Juans in the north, former cheap refuges for dropouts and back-to-the-landers are becoming enclaves of the rich. In 1999, for the first time, a waterfront home on slide-prone Vashon sold for more than a million dollars. I listened as Emma Amiad, a Vashon real estate agent, fretted over the boom that is boosting her business: "It's getting so people who work on the island can't afford to live here, and people who grow up here can't stay." To preserve the social fabric, she and other community-minded Vashonites were campaigning to build subsidized housing.

Gentrification has its environmental upside. Pulp mills and other plants have been closed or cleaned up by the score since the 1970s, helping the Sound's waters recover from a century of abuse. "I think Puget Sound is in pretty good shape and is improving," says Roland Anderson, an invertebrate biologist who heads the Seattle Aquarium's Puget Sound Team. Indeed, the octopuses and other mollusks he studies appear to be increasing. Compared to urban estuaries back East and in Europe and Asia, the Sound is pristine; the Chinese pay a small fortune for its geoducks because their own waters are too dirty to grow them.

This progress is also partly due to alarms that went up in the 1980s, after federal scientists found tumors and ravaged livers in bottomfish and identified sixty-five "toxic hotspots" around the Sound. Shellfish-closure signs popped up on more and more beaches, and even wading was banned at Seattle's popular Gasworks Park on Lake Union, which feeds into the Sound. As one expert put it, Puget Sound was dying "the death of a thousand cuts." We had become Wasgos in reverse: Instead of bringing life up from the sea, we dumped death into it.

Popular sentiment rallied for cleanup and protection. Regulators shut down

an ancient copper smelter that spewed arsenic over Tacoma and Vashon, and wood-treatment plants that dumped creosote into Bainbridge Island's Eagle Harbor and Seattle's Duwamish Waterway. In 1985, "the Year of the Sound," the state established a new Puget Sound Water Quality Authority. Metropolitan Seattle's sewage agency, which had long resisted federal orders to upgrade its treatment plants, finally relented.

The 1989 *Exxon Valdez* oil spill in Alaska prompted some of the action that Puget Sound's defenders had long sought to prevent a similar spill in it. Congress ordered that tankers and freighters be escorted by tugboats in the waters east of Port Angeles, and that the oil companies switch to double-hulled tankers (which are much less prone to spill in an accident) by 2010.

But when the back-patting was over, the steam went out of "Save the Sound" and political attention shifted elsewhere. Prodded by industry interests and rival agencies, the Washington Legislature shut down both the Water Quality Authority and the state's spill-prevention agency. Halfway to the 2010 deadline, the oil industry had made virtually no progress toward double-hulled tankers. Activists and state officials complained that federal law left a glaring gap in oil-spill protection: Ships needn't have tug escorts in the Strait of Juan de Fuca *west* of Port Angeles, even though that channel has more traffic than the inland waterways where tugs were required. In 1999 a fatal explosion shut down a leaky fuel pipeline in Bellingham, causing even more gas and oil to go by tanker instead—and pointing up just how quickly disaster can strike when petroleum products are transported.

Meanwhile, scientists began sounding the alarm on the invasive species that have begun colonizing the Sound after hitchhiking here in ships' ballast water and seafood packing crates. Because of its size and remoteness, Puget Sound hasn't shown effects as severe as those in other invaded estuaries. Some of the most notorious globe-trotting shellfish predators—the Chinese mitten crab, veined Rapa whelk, and European green crab—hadn't yet arrived here. But spartina grass, which turns fertile tideflats into sterile saltmarshes, was popping up, and the others were expected soon.

The far-flung pollution that comes with urban sprawl—from septic leaks and lawn and roadway runoff—is harder to trace and correct than sewage or pulp-mill outfalls. The current state of the Sound's shellfish may come to seem like a brief honeymoon, before the green crabs and algae blooms set in.

SOME OF THE MOST NOTORIOUS GLOBE-TROTTING SHELLFISH PREDATORS—THE CHINESE MITTEN CRAB, VEINED RAPA WHELK, AND EUROPEAN GREEN CRAB—HADN'T YET ARRIVED HERE.

105

THE SEAWOLF'S FATE

·

In 1999, the unthinkable happened: Puget Sound's wild Chinook salmon and Hood Canal's wild chum, fish that once seemed to run without limit, the cornerstones of culture and prosperity here, were listed as threatened species. And federal authorities began considering whether to also list some of the Sound's most important marine and bottomfish species—cod, herring, hake, pollock, and three species of rockfish.

The marine fishes' decline is vexing enough, stemming as it does from a host of complex causes: pollution, overfishing, oceanic warming, the loss of inshore spawning beds. But the salmon's plight is even more troubling: It reverberates throughout the ecosystem and cuts to the heart of our identity as people of the inland sea and heirs to an ancient salmon culture.

The salmon's woes arise from their role as mediators between land and sea. In symbolic terms, they are our resurrection myth, forever reborn from the sea, going down to it as puny fry and returning, like the Wasgo, as mighty warriors. They bring the sea's wealth up to land, but they also bear away whatever ills we visit on the land. Everything that blocks streams, clogs streams, dirties streams, poisons streams, heats up streams, dries up streams, or even floods streams at the wrong time prevents salmon from spawning. And that includes just about everything humans do on the land—farming and clearcutting, building roads and

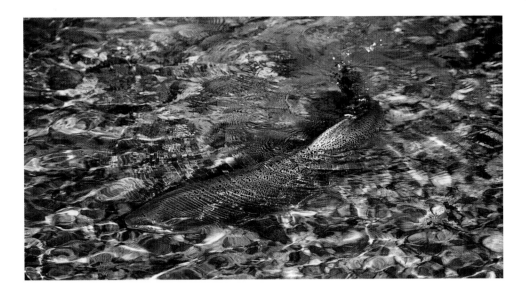

◄ **End of the watery trail: spawners near their final redd, on the Skykomish River.**

shopping centers, even smothering their yards in plastic to keep them weed-free and picture-perfect. The more humans, the more impact. And humans here show as much predilection for sport-utility gas hogs, oversized suburban chateaux, exquisitely sprayed and fertilized lawns, unwalkable cul-de-sacs, and sprawling parking lots as anywhere else—plus a special knack for killing the thing they love. To dwell right on the Sound, they build massive bulkheads that wreak havoc on eelgrass beds and tidal habitats. To enjoy unbroken views of the Sound, they buy hills and ridgetops and shave them bald, inviting erosion and all its downstream impacts.

Sometimes you need a spaceman's-eye view to appreciate the cumulative impact of uncounted isolated abuses. The American Forestry Association analyzed satellite photos of 3.4 million acres around the Central and South Sound and found that between 1972 and 1996, heavily forested areas declined by 37 percent; acreage with very little vegetation more than doubled, to 57 percent of the total. Since European-American settlement began, the Sound itself has lost about three-quarters of its delta wetlands and a third of its eelgrass beds, key spawning areas for many marine species.

But hope still lies in the salmon themselves. Nothing has galvanized the region's imagination and conscience like the struggle to save the salmon. City, county, and state governments have drafted billion-dollar plans to restore and protect the streams the fish need. Each year, thousands of schoolchildren incubate salmon fry in classroom tanks, then release them into native streams. As actual fish enhancement, this is a vain exercise: The baby fish surely die, and might harm native stocks if they didn't. As an attention-getter, it's unbeatable. I

NOTHING HAS GALVANIZED THE REGION'S IMAGINATION AND CONSCIENCE LIKE THE STRUGGLE TO SAVE THE SALMON.

107

still recall my daughter, then in grade school, telling me I couldn't eat coho anymore because *her* salmon were coho.

"If we want to keep Puget Sound clean, we need to have salmon in it," John Sayre, then director of the conservation group Long Live the Kings, told me years ago as we watched the outsized fish make their way up a trickle of a stream from Hood Canal, seeking for a redd to spawn in. "If we lose the salmon, who the hell is going to care about the water? You're not going to get people cranked up for any other animal."

Except, perhaps, for the magnificent orca. One of the first rumblings of save-the-Sound consciousness was the popular outcry that rose in the 1970s against the capture of young killer whales for aquariums and amusement parks—a sentiment rekindled by the movie *Free Willie* and the ensuing million-dollar campaign to free Keiko, the captive whale cast as Willie. Now the region's resident orcas face perils more insidious than captors' nets. Their numbers, which grew in the 1980s and early 1990s after captures were banned, began plummeting in the late 1990s. In 1999 a Canadian government panel listed the local pods as "threatened," though such listings are toothless in Canada. Across the border, scientists and conservationists began mustering to seek protection for the orcas under the U.S. Endangered Species Act.

But what should we protect them from? The decline in salmon, the killer whales' primary food, doubtless plays a part in their decline, as may harassment by whale-watching boats. But the main factor, the experts at the Whale Museum and Center for Whale Research in Friday Harbor believe, is soaring levels in their tissues of the industrial chemicals known as PCBs—as much as forty times the level of "extreme toxicity" in laboratory animals.

A ghost from our blithe polluting past had come back to haunt Puget Sound's *other* peak predators. The United States banned ocean dumping of PCBs in 1977—by chance, the year the killer-whale captures ended. But these carcinogenic, immunity-wrecking chemicals are stubbornly persistent, lingering in sediments and traveling up the food chain. PCBs are still used in Asia and many other parts of the world, and they may travel east across the Pacific, just as the nutrients that nourish Puget Sound do: on the wind, on ocean currents, or in the tissues of wide-foraging salmon. And the salmon's decline has forced orcas to also hunt bottomfish, which pick up even more sediment pollutants. Call it a toxic time bomb, or a curse rebounding. Or call it the Seawolf's fate.

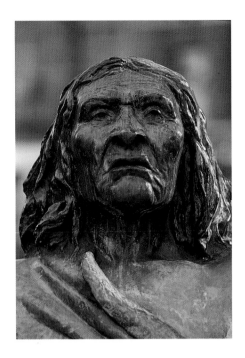

THE WISE WASGO

.

In the tale's classic version, the man in the Wasgo's skin works his way like a bad chemical up the marine chain, killing ever bigger creatures: salmon, seals, whales. Finally he achieves the supreme feat—three killer whales in a single dive! Having looted the sea, he falls to the ground dead.

The warning speaks across the centuries, past all our booms and busts, our proud ships and sunken bridges, through all the delight we have taken and all the insults we have inflicted on these patient, generous waters. Even they can only take so much, and we can only take so much from them. In the end, if we do not learn when to stop, we will kill for the last time and die ourselves.

But the Wasgo's tale is a cautionary fable, not a prophecy of doom. The lesson it teaches is one that is fundamental to all mythologies: humility. Humility in the face not of misery and loss but of gifts too great to be counted: wealth such as has never been known in human history, a beauty found nowhere else on this planet. We who live now upon Puget Sound, or who visit here only briefly, are favored beyond our dreams and our desserts. Whether those who will come after us will be so fortunate depends, quite simply, on us. It is a glorious challenge: to savor, to cherish, and to preserve. And it is a challenge with implications far beyond our inland sea.

Alan Thein Durning, director of Northwest Environmental Watch, puts the

▲ In the famous 1854 speech attributed to him, Chief Sealth (Seattle), whose likeness now stands in Pioneer Square, prophesied, "And when the last red man shall have perished from the earth and his memory among white men shall have become a myth, these shores shall swarm with the invisible dead of my tribe."

WE WHO LIVE NOW UPON PUGET SOUND ARE FAVORED BEYOND OUR DREAMS AND OUR DESSERTS. WHETHER THOSE WHO WILL COME AFTER US WILL BE SO FORTUNATE DEPENDS ON US.

109

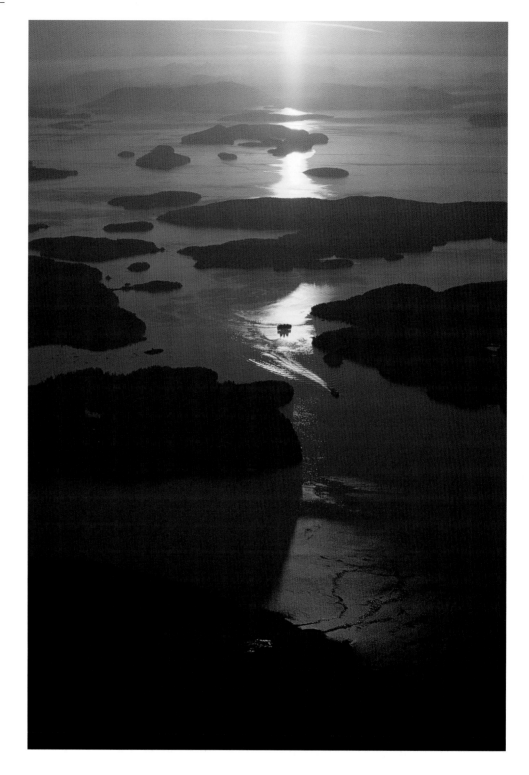

▶ Taking the long view: The sun sets over the San Juan Islands. ▶ ▶ Fog cloaks the Skagit Valley on a chilly October morning. ▶ ▶ ▶ The moon rises over the Cattle Point Lighthouse on San Juan Island, seen from Lopez Island's Shark Reef Beach; Vancouver Island lies beyond.

question in his book *This Place on Earth:* "The Pacific Northwest is the proving ground. It is more ecologically intact than anywhere else in the world." If people cannot find a balance between nature and lifestyle here in "the greenest part of the richest society in history," where can they? But if Northwesterners can learn to live lightly on the land and water, they will show the rest of the world the way.

These woods and waters are still young, and ready to nourish and delight for millennia to come. The wise Wasgo knows when to stop looting and find hope, not plunder, in the sustaining sea.

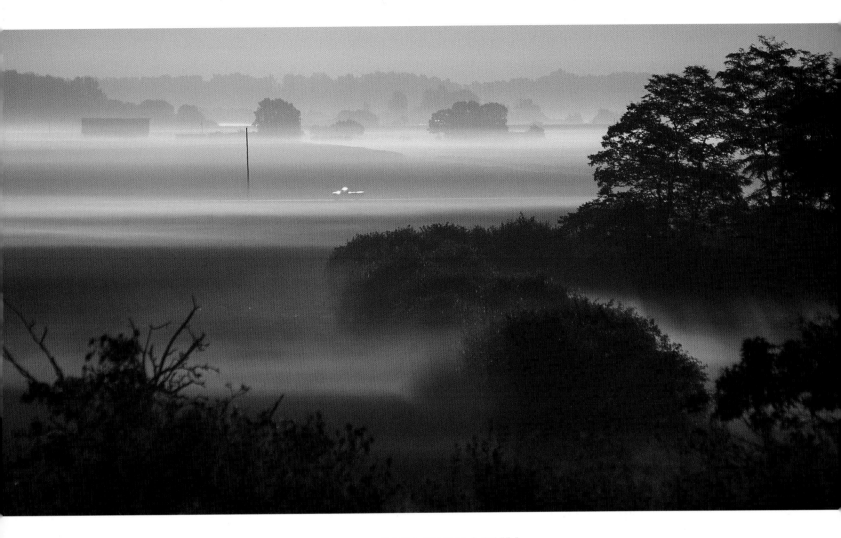

BIBLIOGRAPHY

Adamson, Thelma. *Folk-tales of the Coast Salish.* New York: The American Folk-lore Society, 1934.

Andrade, Manuel J. *Quileute Texts.* New York: Columbia University Press, 1931.

Barbeau, Marius. *Haida Myths Illustrated in Argillite Carvings.* Ottawa: National Parks Branch, National Museum of Canada, 1953.

Buerge, David. "Indian Lake Washington." *The Weekly.* August 1, 1984, p. 29.

Chasan, Daniel Jack. *The Water Link: A History of Puget Sound as a Resource.* Seattle: Washington Sea Grant, 1981.

Clark, Ella H. *Indian Legends of the Pacific Northwest.* Berkeley: University of California Press, 1953.

Downing, John. *The Coast of Puget Sound: Its Processes and Development.* Seattle: Washington Sea Grant, 1983.

Durning, Alan Thein. *This Place on Earth: Home and Practice of Permanence.* Seattle: Sasquatch Books, 1996.

Eells, Myron. *The Indians of Puget Sound: The Notebooks of Myron Eells,* edited by George Pierre Castille. Seattle: University of Washington Press, 1985.

Egan, Timothy. *The Good Rain: Across Time and Terrain in the Pacific Northwest.* New York: Vintage Books, 1991.

Kozloff, Eugene N. *Seashore Life of the Northern Pacific Coast.* Seattle: University of Washington Press, 1983.

Kruckeberg, Arthur. *The Natural History of Puget Sound Country.* Seattle: University of Washington Press, 1995.

Mathews, Daniel. *Cascade-Olympic Natural History.* Portland: Raven Editions, 1988.

Morgan, Murray. *Puget's Sound: A Narrative of Early Tacoma and the Southern Sound.* Seattle: University of Washington Press, 1979.

Puget, Peter. "The Vancouver Expedition: Peter Puget's Journal of the Exploration of Puget Sound, May 7–June 11, 1792, with an introduction by Lt. Commander Bern Anderson." *Pacific Northwest Quarterly*, Seattle, April 1939.

Reid, Bill, and Bringhurst, Robert. *The Raven Steals the Light.* Seattle: University of Washington Press, 1984.

Rogers, Eugene. *Flying High: The Story of Boeing and the Growth of the Jetliner Industry.* New York: Atlantic Monthly, 1996.

Vancouver, George. *A Voyage of Discovery to the North Pacific Coast and Round the World.* London: G. G. and J. Robinson, 1798.

Winthrop, Theodore. *The Canoe and the Saddle: Adventures Among the Northwest Rivers and Forests and the Isthmiana.* New York: J. W. Lovell, 1862.

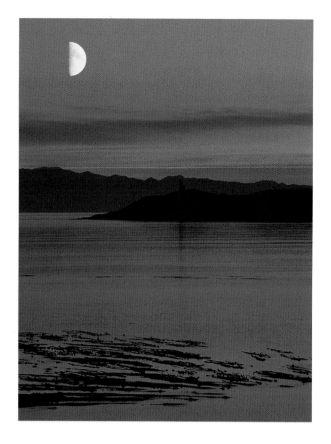

ACKNOWLEDGMENTS

I'm in debt to a myriad of people throughout the Sound, who took me to places I would have never seen without their assistance. In particular, I would like to thank Marshall Terry, who flew me on countless aerial shoots during this three-year project and never once told me I was nuts when I requested a ridiculous maneuver.

I would also like to thank Shannan Swanson of Airial Balloon in Snohomish for a great ride. Ditto Phil Taylor, who's hauled me around several times over the past dozen years in his Travelair biplane. (I keep telling him, just one more flight and we'll have that shot.)

Thanks are due as well to John Adams of Lopez Kayaks, who paddled me out to an amazing sea cave, and to Bill Christianson, captain of the SV *Chinook*, who showed me the waters around San Juan Island as I'd never seen them before.

Finally, my sincere appreciation to all those who flung the doors open and let me come in and photograph their unique corner of the Sound. These locations include Emerald Downs Racetrack, the Fish and Wildlife Hatchery at Sultan, Nichols Brothers Boat Builders, and Louisiana-Pacific Lumber. —*TT*

Thanks are due to many who, whether they knew it or not, helped me over the years to know and appreciate this *mare nostrum*. Special thanks to several otherwise uncredited souls whose aid and expertise enriched the text: Fred Felleman, the ocean's most ardent advocate; fearless naturalist David G. Gordon; Richard Strickland, a walking oceanographic encyclopedia; Bill Holm, a keeper of the lore; Joel Rogers, a samurai of kayak and camera; and Brad Warren, who should write the full saga of the local fisheries. David Brewster, Knute Berger, and other editors past and present at the *Seattle Weekly* gave me the go to pursue many stories around the Sound and the time to write this one. Ellen Wheat, editor and editorial conscience, knew when to play out line and when to tug the hook. And Lucia Hansen helped me find the right words, and much more. —*ES*